IMAGES
of Rail

Staten Island Rapid Transit

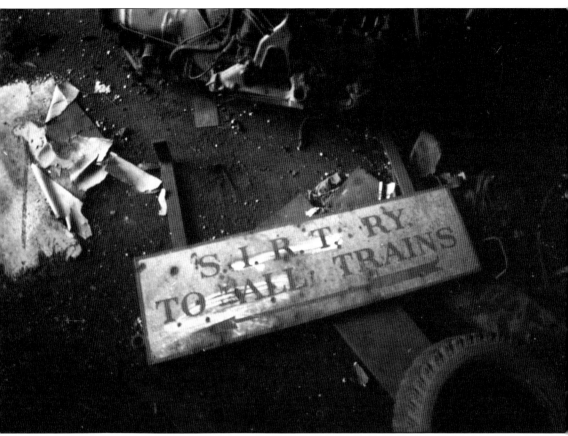

The seeds for this book were planted nearly 30 years ago, when the author and his father found this discarded sign inside the carpenter shop at St. George Yard. It once directed travelers to the Staten Island Rapid Transit platforms adjacent to the ferry terminal. The sign was most likely removed in the early 1970s, when the Chessie System sold off the passenger service to the New York City Transit Authority. (Gaspar Pitanza.)

ON THE COVER: Alco S-2 locomotives, like no. 9031 pictured here at St. George Yard on a festive occasion in June 1966, were the backbone of the freight fleet on Staten Island. Freight cars from all over the country were transferred to car ferries at the yard and floated to other rail terminals all over New York Harbor. (Chesapeake & Ohio Railroad Historical Society collection, CSPR 11642.CN4.)

IMAGES of Rail
STATEN ISLAND RAPID TRANSIT

Marc Pitanza

ARCADIA
PUBLISHING

Copyright © 2015 by Marc Pitanza
ISBN 978-1-4671-2338-9

Published by Arcadia Publishing
Charleston, South Carolina

Printed in the United States of America

Library of Congress Control Number: 2014953453

For all general information, please contact Arcadia Publishing:
Telephone 843-853-2070
Fax 843-853-0044
E-mail sales@arcadiapublishing.com
For customer service and orders:
Toll-Free 1-888-313-2665

Visit us on the Internet at www.arcadiapublishing.com

To Ed Bommer, whose tireless research has inspired a new generation of historians; and to Yenory, Dylan, and Luna for their unending love and support.

Contents

Acknowledgments		6
Introduction		7
1.	A Transportation System for Staten Island	11
2.	Route of the Royal Blue	19
3.	Arlington Yard and Port Ivory	31
4.	The Travis Branch	41
5.	North Shore Subdivision	47
6.	St. George Yard and Waterfront Terminal	59
7.	Clifton Shops and the Line to South Beach	79
8.	The Perth Amboy Subdivision	93
9.	Staten Island Rails in the 21st Century	117
Bibliography		127

Acknowledgments

This book would not have been possible without the gracious contributions of the following talented photographers: Tom Flagg, Gerald Landau, Tom Nemeth, and Don Spiro. I want to thank James Harris, Charles Houser, Bob Liljestrand, H. Gerald MacDonald, James Mischke, Robert Pennisi, David Pirmann, and Michael Saitta for sharing their collections with me. I would like to thank Tom Griffiths and Robert A. Miller for being so generous with their time and for graciously allowing me to use their superb images in the creation of this book.

A very special thank-you goes to Ed Bommer. He is the one individual who paved the way for this book through his research, writing, and dedication to Staten Island transportation history. Ed also graciously provided me with access to his collection of photographs, maps, and SIRT ephemera. Arcadia author and railroad historian David Keller helped a great deal in the creation of this book by providing scans of rare SIRT photographs.

I also would like to thank my parents, Connie and Gaspar Pitanza, for their support of this project and for sharing memories and photographs of the SIRT. I want to acknowledge the encouragement of my sister Kristin, who supported this book project from the very beginning. I want to express my gratitude to archivists Nick Fry, Al McEvoy, and Christopher Winslow at the B&O Railroad Historical Society for making scans for this book. I would like to thank Tom Dixon of the C&O Historical Society for allowing me to use the stunning image that graces the cover of this book.

I want to thank members of my unofficial e-mail discussion group: Ciro Compagno, Brian Deforest, Carl Dimino, and Steve Phetterplace. I would like to thank John Teichmoeller of the Rail-Marine Information Group for having faith in my knowledge and my ability to give a presentation about this little railroad in 2009.

I wish to thank my title manager at Arcadia Publishing, Sharon McAllister, for her expert guidance and careful attention to all of my questions every step of the way. She helped make the creation of this book a truly great experience.

INTRODUCTION

The Staten Island Rapid Transit Railway had two personalities. First, it was a commuter railroad, with cars that were very similar to the subway cars used across the bay in Brooklyn and Manhattan. It was also a freight railroad that handled a majority of the Baltimore & Ohio's traffic for New York Harbor. The busy passenger line was never connected to the New York City subway system. The freight aspect of the railroad was linked to a national system by a bridge to friendly connections in New Jersey. Despite its isolation, Staten Island proved to be a strategic location close to the New York waterfront. Several eastern trunk-line railroads showed interest in building on Staten Island's inexpensive land, including the Pennsylvania and Philadelphia & Reading. The Baltimore & Ohio, a latecomer, was the unlikely victor.

The first Staten Island Rail Road was incorporated in 1836. The line was planned from Vanderbilt's Landing (modern-day Clifton) to Tottenville. In 1838, the charter was voided for failure to produce the line. A decade passed before the idea of a railroad for the island came back into the public eye. On August 2, 1851, the Staten Island Railway was organized. William H. Vanderbilt, island resident and son of Cornelius "Commodore" Vanderbilt, became a member of the railroad's board of directors in 1858.

On February 1, 1860, the first passenger train, an inspection trip for stockholders and officials, ran over the line from Vanderbilt's Landing to Eltingville. On April 23, regular passenger service began. On June 2, the line was completed to Tottenville, and islanders celebrated the opening. In Tottenville, passengers could transfer to a ferry to Perth Amboy, New Jersey.

On September 4, 1861, the Staten Island Railway was placed into receivership with William H. Vanderbilt to prevent loss of the locomotives and rolling stock to creditors. William's uncle, Capt. Jacob Vanderbilt, became president of the line. In 1865, the railway took over operation of the NY & Richmond Ferry Company and would later assume direct responsibility for operating the ferry service to Manhattan as well. The Staten Island Railway Company was reorganized at this time. Vanderbilt was slowly building a transportation system for the island. Under "Captain Jake," the SIRR and ferry line earned a modest profit until the unfortunate explosion of the Westfield at Whitehall Street Terminal on July 30, 1871. Both never came out of bankruptcy until after the B&O arrived.

The Staten Island Rapid Transit Company (SIRT) was organized on March 25, 1880. The primary objective of this line was to get control of the east shore piers and ferries and connect them with a short two-mile line between Vanderbilt's Landing and Tompkinsville. Canadian expatriate and Staten Island businessman Erastus Wiman sought to expand the line, and he approached Robert Garrett, president of the Baltimore & Ohio Railroad (B&O), to back the idea of a large rail terminal on the island. Garrett, desperately seeking entry into the lucrative New York market, saw an opportunity in the rail lines of Staten Island.

The first Staten Island Rapid Transit train ran between Vanderbilt's Landing and Tompkinsville on July 31, 1884. This marked the beginning of a very busy era in SIRT history. In 1885, construction

of a tunnel between Tompkinsville and St. George was begun. A small yard was built at St. George, and construction west along the island's north shore continued. Expansion of the line was quite expensive and required construction of a seawall out into the Kill van Kull for nearly two miles. In November 1885, the B&O purchased controlling interest in the Staten Island Rapid Transit Railway Company and would own the line until it was sold in 1985.

The B&O had to now connect its Staten Island rails to the growing national system. In October 1888, the Baltimore & New York Railway was created by the B&O to construct a connection between Cranford Junction, New Jersey, and the Arthur Kill. The line was completed in late 1889 and included strategic interchange points with the mighty Pennsylvania and Lehigh Valley Railroads. A record-breaking 495-foot swing bridge was constructed over the Arthur Kill. On January 1, 1890, the first train, an inspection trip loaded with B&O managers and executives, operated from St. George to Cranford, New Jersey.

Early in the 20th century, the City of New York instituted antismoke ordinances on all of the railroads that ran into the city. At first, the law banned all bituminous coal–burning locomotives within city limits. The SIRT and B&O replaced their locomotives with anthracite-burning engines. In 1923, New York passed the Kauffman Act, which singlehandedly put the nail in the coffin for steam operation in the city. In the following year, the B&O began electrification of its passenger lines on the island. The track was upgraded to 100-pound rail, and a 600-volt outside third-rail power distribution system was used to power the trains. New steel electric passenger cars were ordered from the Standard Car Company of Hammond, Indiana. The cars were designed to be compatible with the BMT transit lines in Brooklyn. Shafts for a rail tunnel under the Narrows were sunk both at Brooklyn and near Clifton on the island. The long tunnel, intended for passenger, freight, and rapid transit (subway) trains, would have been a strategic marketing tool for the B&O. It was rumored that the governor of New York, Alfred E. Smith, had a considerable number of shares in the Pennsylvania Railroad and opposed the idea of B&O running freight trains in subway tunnels. Officially, however, the project simply ran out of financing.

Electrification of the island's passenger lines was completed by November 1925. The major freight yards at Arlington and St. George were not electrified, because the cost was too prohibitive. New York State granted the B&O a five-year extension to comply with the Kauffmann Act. The onset of the Great Depression and World War II made compliance impossible.

The new electric cars were quieter, cleaner, and faster than the aging steam fleet. The new dark-green cars were not as visible as their steam counterparts, and in the early 1930s, several deadly accidents at grade crossings across the island raised the demand for elimination of the crossings. At this time, much of the line was dropped into cuts, and some of the line was raised above street level on concrete trestles.

In 1943, the first diesel locomotive, a 65-ton, 400-horsepower General Electric switcher, arrived on Staten Island. It was followed by eight S-2 switchers from the American Locomotive Corporation. These locomotives became the backbone of freight operations on the island. The last steam locomotive left Staten Island in 1946.

In 1948, the city board of transportation took over all of the bus lines on Staten Island. The board cut existing fares in half, and rapid-transit customers shifted to the cheaper bus lines to get around the island. In March 1953, passenger service on the North Shore and South Beach branches was eliminated, and by 1955, the third rail was removed. The South Beach branch was abandoned and ripped up, while the North Shore remained in service for freight trains only.

In 1957, the aging Arthur Kill swing bridge was knocked off its center pier foundation by a passing oil tanker. Freight traffic for the island was routed through float bridges, with most of B&O's freight traffic for the New York area forwarded to the Central Railroad of New Jersey yards at Jersey City. The old swing bridge was replaced in 1959 with a state-of-the-art, 558-foot vertical lift bridge. It still holds the record as the longest bridge of its type in the world. The industrial track on the west shore of the island, built in the 1930s, was extended to serve a new Consolidated Edison power plant in Travis. At this time, the SIRT began to handle long-unit coal trains from West Virginia to the plant.

In 1971, the passenger line running from St. George to Tottenville was purchased by the New York City Transit Authority. This part of the line was reorganized as the Staten Island Rapid Transit Operating Authority (SIRTOA). New R-44 subway cars were purchased to replace the ancient Standard Steel cars. The B&O, through a merger with the Chesapeake & Ohio, became part of the larger Chessie System. The freight operation on the island was renamed the Staten Island Railroad Corporation.

In 1976, the major bankrupt trunk lines of the Northeast were merged into Conrail. Chessie System lost its friendly connections in New Jersey, and its Staten Island rails were becoming increasingly isolated. Staten Island's major rail-served industries began closing; by 1981, car-floating at St. George yard had ceased. In April 1985, lack of business and access forced Chessie System to sell the line to the New York, Susquehanna & Western Railroad, which was owned by the Delaware Otsego Corporation.

The Susquehanna embargoed the track east of Elm Park on the North Shore Line. This action cut off rail freight traffic to St. George. Procter & Gamble, the line's largest customer, closed its doors in 1990. The Susquehanna operated sporadically on Staten Island until the Arthur Kill Bridge was taken out of service on June 25, 1991. The North Shore line went dormant after 100 years of continuous service.

In 1994, the Metropolitan Transportation Authority (MTA) reinstituted the line's original name; the passenger portion of the line is now known as the MTA Staten Island Railway. In the late 1990s, the City of New York and its roads were gridlocked with truck traffic, and a reactivation of Staten Island's defunct rails was presented as a solution. Studies showed that a rail line and container terminal could remove 90,000 trucks a year from Staten Island's congested roads. In summer 2003, work began on laying new track in Arlington Yard and down the Travis Branch. The New York Container Terminal opened its doors for business on the old Procter & Gamble site, and train service began in October 2006. In April 2007, train service began to the new Fresh Kills transfer facility in Travis. New York City's trash now moves off the island in bright orange container trains. The Arthur Kill Bridge is back in service and sees up to five trains a day. It is truly a rail freight renaissance for Staten Island

This book is the first volume published on the railroad in over 50 years. It offers a complete study of the line and its facilities, including its obscure branches and lesser-known customers. This book is a photographic tour of a unique branch line that operated in the shadow of Gotham. So, come along as we "Ride the Rapid!"

One
A Transportation System for Staten Island

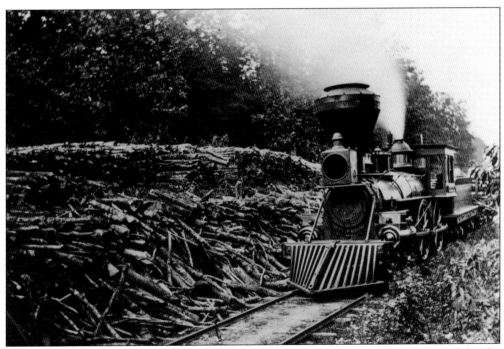

In the early days, the Concord woods provided a cheap and plentiful source of fuel for the locomotives on the Staten Island Railway. In this 1866 photograph, locomotive No. 2, the *Edward Bancker*, takes on wood at Concord. The steam engine was a March 1860 product of the New Jersey Locomotive & Machine Works. (Photograph by John J. Crooke, courtesy Edward F. Bommer.)

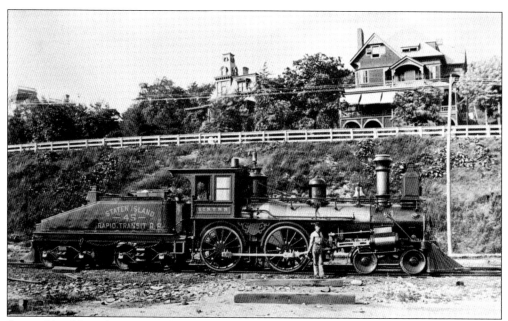

Staten Island Rapid Transit Rail Road locomotive No. 45 lays up at St. George on June 30, 1886. It was one of the first Baltimore & Ohio engines to be transferred to the island. Patronage of the North Shore line had swelled when Buffalo Bill's Wild West Show, which started its national tour on Staten Island, opened to the public only a year earlier. (G.E. Votava collection, courtesy David Keller.)

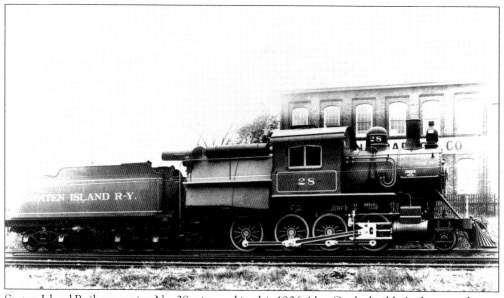

Staten Island Railway engine No. 28, pictured in this 1906 Alco Cooke builder's photograph, was a Class E type 2-8-0 locomotive with Wootten firebox. The camelback type became a favorite design of the railroad until the end of steam service in 1946. (Bob's Photos, courtesy Edward F. Bommer.)

The freight yard at St. George, shown at nearly full capacity in the winter of 1911, was built by the B&O to tap into the lucrative New York freight market. Cars were placed on ferries and floated to off-line terminals all over the harbor. Freight was also transferred to railroad-owned barges and shipped to waterside industries without a rail siding. The building in the background is the Pier 5 warehouse. (B&O Railroad Historical Society.)

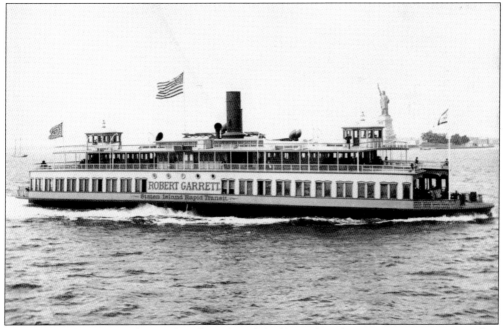

When the Baltimore & Ohio Railroad purchased the line, it bought a transportation system that included ferry service to Manhattan and Perth Amboy, New Jersey. In 1888, two state-of-the-art ferries were delivered to the line. The *Robert Garrett* (pictured) was named after the president of the B&O at the time. The innovative, double-ended design helped speed docking at terminals at both ends. (Edward F. Bommer.)

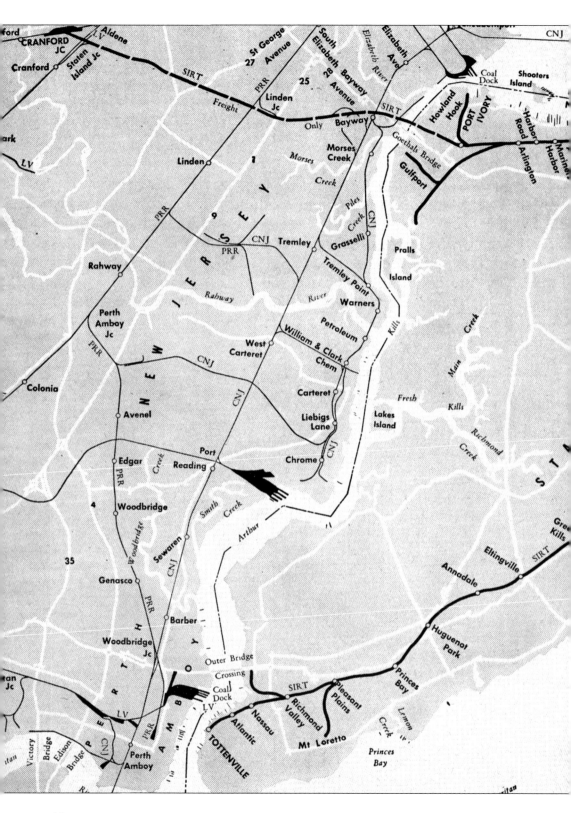

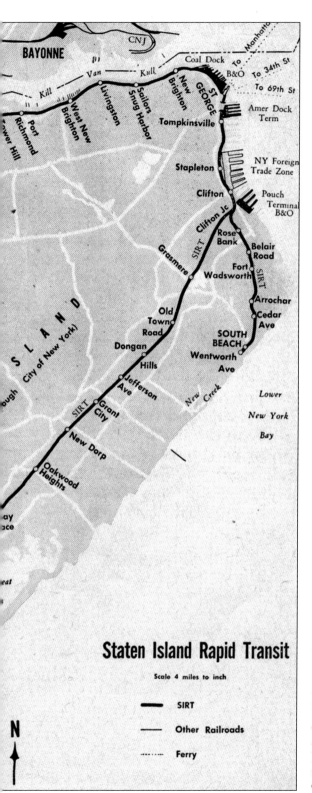

This excellent map of the Staten Island Rapid Transit Railway in 1951 shows a mostly complete look at the line's many branches and stations. It also illustrates the line's strategic interchanges with the Central Railroad of New Jersey, Lehigh Valley, and Pennsylvania main lines in New Jersey. The branch to Gulfport on the island's west shore was extended to Travis in 1957 and then to Fresh Kills in 2005. (©2014, *TRAINS* magazine, Kalmbach Publishing Co., reprinted with permission.)

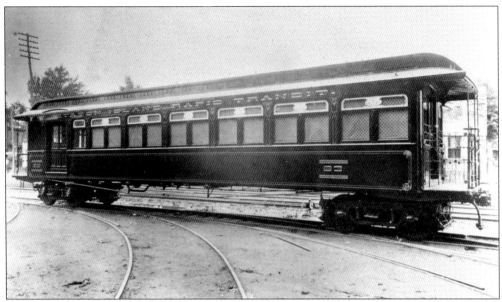

Staten Island Rapid Transit combine No. 83 is the subject of this 1892 builder's photograph from the Jackson & Sharp Car Company. The baggage compartment was used to carry parcels, mail, newspapers, and various express traffic for towns along the line. (David Keller.)

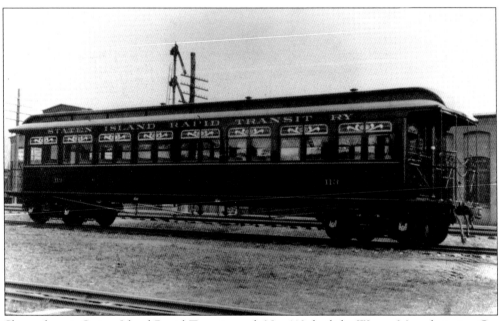

Shown here is Staten Island Rapid Transit coach No. 113, built by Wason Manufacturing Co. in 1910. The coach was one of the last wooden cars produced for the line. Passenger cars with fancy Victorian detailing were still common at this late date. (Bob's Photos, courtesy Edward F. Bommer.)

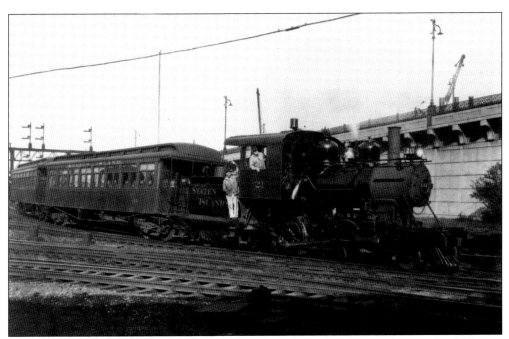

Class R Forney locomotive No. 21 was built at the B&O's Clifton shops on Staten Island. Here, it departs St. George for Tottenville with a short train made up of Wason coaches. This 1924 photograph encapsulates the steam era on the Staten Island Rapid Transit. (Edward F. Bommer.)

New York City antismoke ordinances in the early 20th century set out to ban the use of coal-burning locomotives within city limits. In the 1910s, the B&O showed a great interest in connecting its Staten Island lines with the BMT subway system in Brooklyn. Electrification of the island's rails seemed inevitable. This GE advertisement in a 1925 *Railway Review* proudly shows the importance of the project. (Author.)

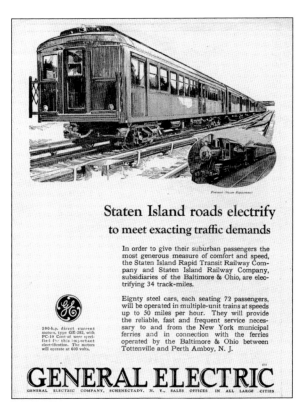

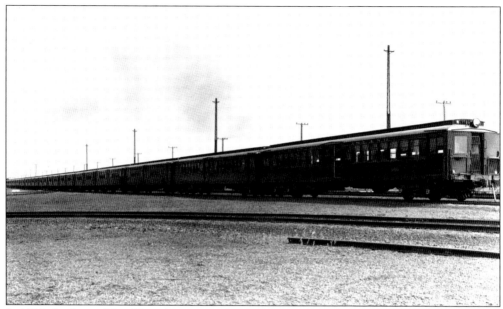

In 1924, the Staten Island Rapid Transit ordered 90 new multiple-unit electric cars from Standard Steel Car Company of Hammond, Indiana. The sparkling new cars, led by motor No. 303, are pictured at the manufacturer's lot awaiting delivery to Staten Island. The cars remained in service until 1973. (Michael Saitta collection, courtesy Edward F. Bommer.)

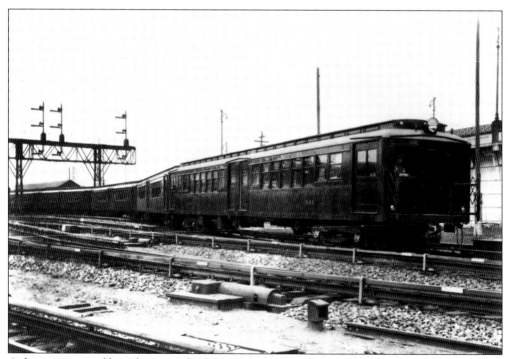

A five-car train of brand-new, multiple-unit electrics pulls out of the St. George Terminal in December 1925. The train was most likely on a training run down the South Beach branch. The line began resembling an interurban railroad. (Edward F. Bommer.)

Two

Route of the Royal Blue

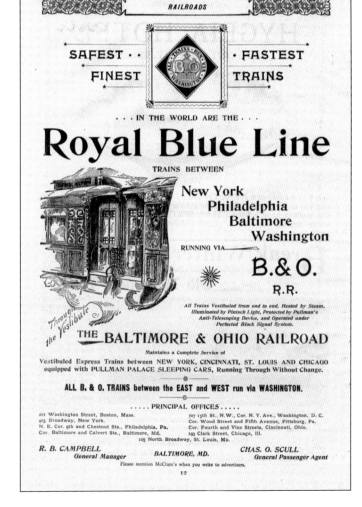

In the late 19th century, the Baltimore & Ohio was desperate to get a foothold in Gotham and have a railhead at New York Harbor. The image of the glamorous Royal Blue Line was created for its passenger service between Washington, DC, and New York. This vintage advertisement sells the service as fast, comfortable, and safe. (Author.)

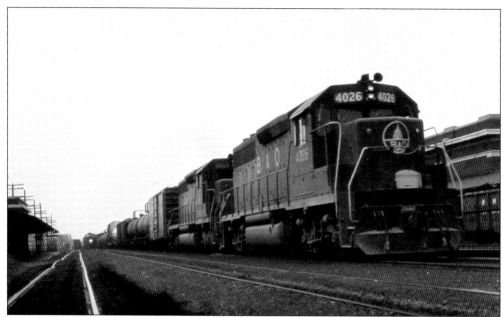

The Baltimore & Ohio main line ended at Park Junction near Philadelphia. The B&O used trackage rights over the Reading Railroad to Bound Brook, New Jersey; there, it switched to the Central Railroad of New Jersey tracks for the rest of the trip to Jersey City. In January 1972, B&O No. 4026 leads a freight through the Bound Brook station. (Photograph by Paul Carpenito, courtesy the author.)

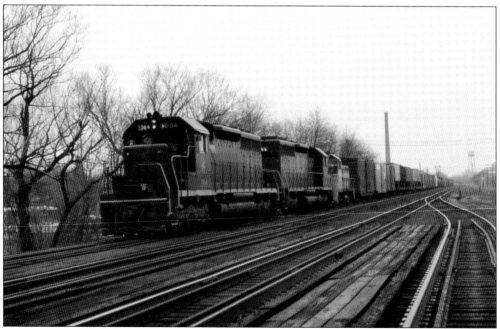

In April 1976, Central Railroad of New Jersey No. 8342, a SD40 dressed in B&O blue, pulls a freight through Bound Brook, New Jersey. The third locomotive in the consist is B&O NW2 No. 5079, painted in the bright Chessie scheme. This locomotive is probably heading for Staten Island to help with switching duties. (Photograph by Paul Carpenito, courtesy the author.)

Passenger trains bound for New York terminated across the Hudson River in Jersey City. This April 28, 1957, B&O passenger train schedule shows major destinations in Manhattan that were served by the railroad's motor-coach service. Patrons transferred to coaches that were loaded onto ferryboats at the CNJ Jersey City Terminal. (Author.)

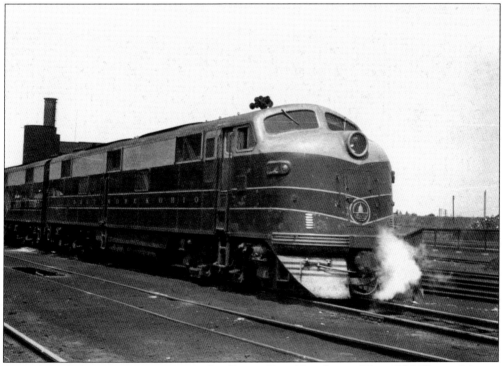

Several B&O luxury trains terminated at Jersey City, New Jersey. Here, GM Electro-Motive Division E7A locomotives wait for their next assignment at the terminal. The Diplomat, National, Capitol Limited, and Royal Blue all operated out of Jersey City. (Photograph by Sy Reich, courtesy Bud Laws.)

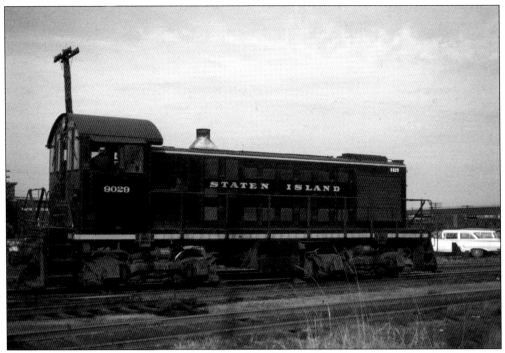

The B&O maintained a small yard for Staten Island–bound freight trains at Cranford Junction. On a cool day in November 1963, Staten Island Rapid Transit Alco S-2 No. 9029 is running light into the yard. (Mac Owen.)

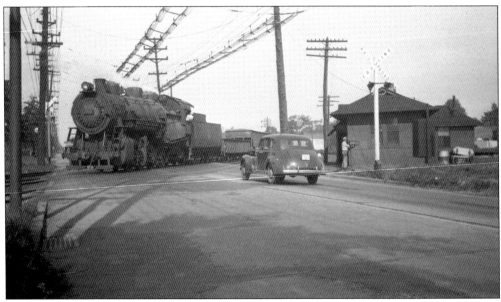

In 1946, Central Railroad of New Jersey 0-8-0 No. 311 backs a cut of freight cars from the SIRT interchange over South Avenue East at Cranford Junction. CNJ crews came into Cranford Junction Yard for pickups if no SIRT crew were available. (Photograph by Stephen Bogart, courtesy David Keller.)

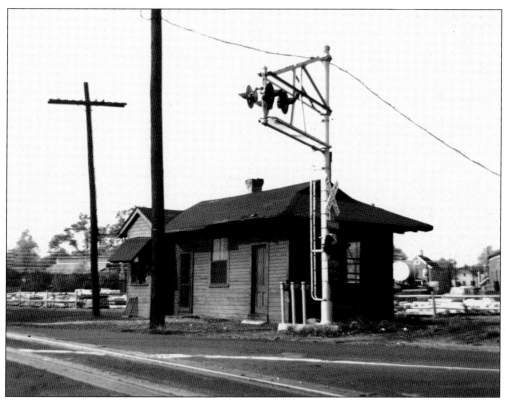

This is the Staten Island Rapid Transit freight and telegraph office, built in 1890, at Cranford. The grade-crossing signals were operated manually from a control box in the office. (Photograph by E. Eccles, courtesy H. Gerald MacDonald.)

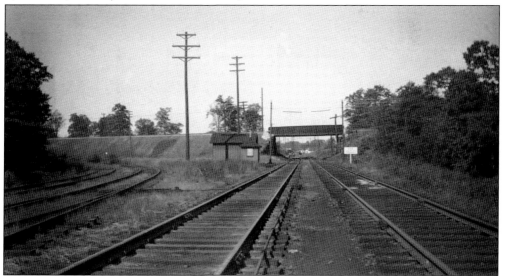

The SIRT/Baltimore & New York Railway tracks are in the foreground in this uncluttered view of Staten Island Junction in 1946. The girder bridge in the distance carries the Lehigh Valley main line over the SIRT. The tracks curving off at left are where freight cars are spotted for interchange with the Lehigh Valley Railroad. (Photograph by Stephen Bogart, courtesy David Keller.)

The Baltimore & New York Railway became a single-track railroad east of Bantas. In this winter 1957 photograph, SIRT Alco S-2 No. 9029 pulls a Staten Island–bound freight through Roselle Park, New Jersey. (David Keller.)

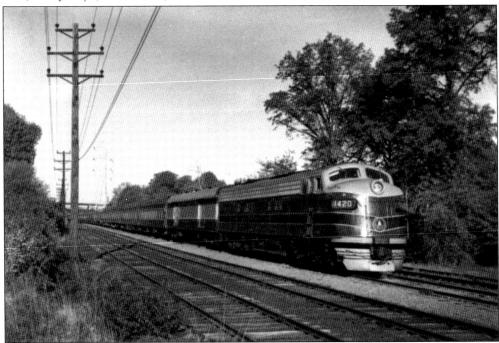

Queen Elizabeth II and Prince Philip rode the SIRT on their way to New York Harbor on October 21, 1957. This is the second of two special trains that carried the royal couple from Washington, DC, to the waterfront at Stapleton, Staten Island. The train is pictured at Amsterdam Avenue in Roselle, New Jersey. One of the trains was for press covering the historic event. (Photograph by William Burke, courtesy Edward F. Bommer.)

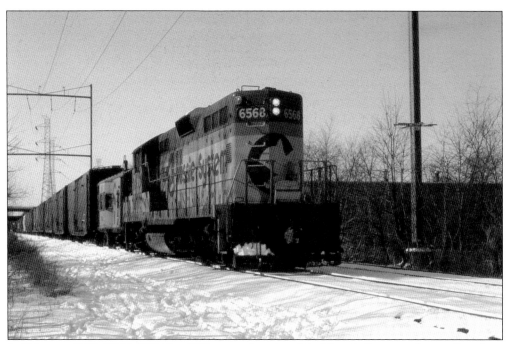

In February 1979, B&O GP9 No. 6568, recently painted in Chessie System colors, pulls a long freight through Roselle Park, New Jersey. Chessie System locomotives became common visitors to Staten Island in the 1970s and 1980s. (Photograph by John Durant, courtesy the author.)

At Linden Junction, the line rises above grade and is carried over the Pennsylvania Railroad Northeast Corridor main line on a double-track, pin-connected truss bridge. B&O Bridge was built in 1887, and the second track was never installed. (Author.)

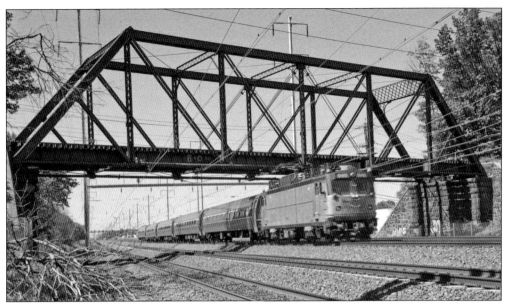

In this photograph, an Amtrak train races under B&O Bridge at Linden Junction. It is hard to believe the bridge's seemingly delicate pin construction carried freight trains for over 100 years. The SIRT interchanged cars with the Pennsylvania Railroad at Linden Junction. (Author.)

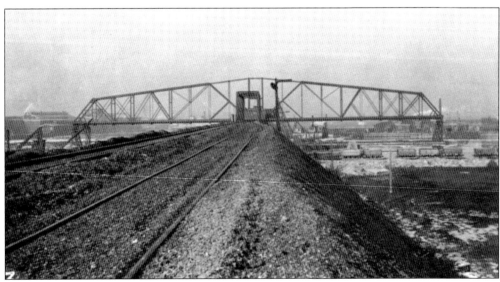

The first crossing over the Arthur Kill, the waterway that separates New Jersey from Staten Island, was a 495-foot single-track, rim-bearing swing bridge. Work began on the record-breaking span in 1887 and was completed in 1889. The bridge is shown in its "open" position in 1911. (B&O Railroad Historical Society.)

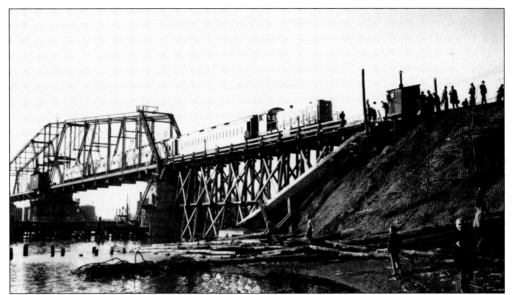

On April 9, 1949, a sun-drenched passenger train led by SIRT Alco S-2 No. 485 pauses on the Arthur Kill Bridge to allow Joint Railfan Trip Committee members a chance to photograph it. The train began its journey in Jersey City. The coaches belong to the Central Railroad of New Jersey. (Edward F. Bommer.)

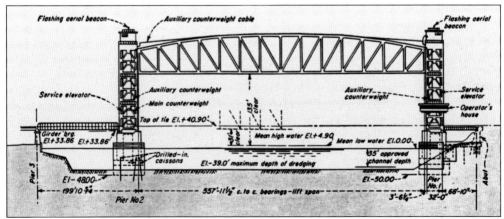

In 1957, the Arthur Kill Bridge was hit by a passing Esso oil tanker, damaging its superstructure and knocking it off its center pier foundation. This drawing shows the general design features of the 558-foot vertical lift bridge, constructed to replace the aging and damaged swing bridge. (Illustration by Parsons, Brinckerhoff, Hall and MacDonald, courtesy Thomas R. Flagg.)

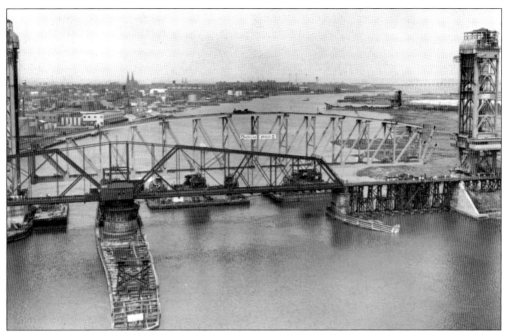

This stunning photograph from June 1959 shows both the older swing bridge and the newer lift bridge. The 2,000-ton lift span was prefabricated, then floated into place. Freight trains started crossing the new bridge in November of the same year. (Photograph by Parsons, Brinckerhoff, Hall and MacDonald, courtesy Edward F. Bommer.)

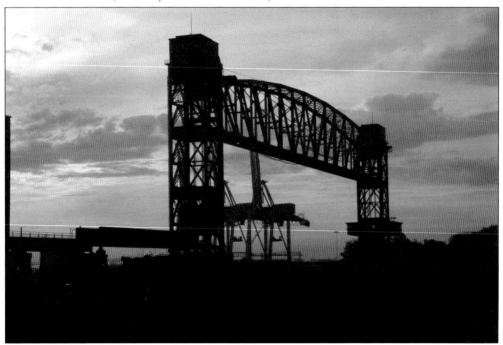

The magnificent Arthur Kill Vertical Lift Bridge stands in the early morning light as a testament to postmodern industrial design. It is functional, yet fluid. The bridge, shown in its "open" position, holds the record for being the longest of its type in the world. (Author.)

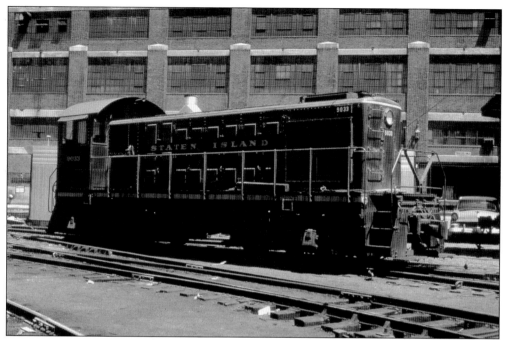

The B&O also had an off-line terminal on Manhattan's West Side. The small yard and warehouse, opened in 1898, was located at West Twenty-sixth Street and could only be reached by carfloat. Staten Island Alco S-2 No. 9033 was photographed working in the yard in May 1961. It was common for small switcher locomotives to be floated around the harbor. (Photograph by Gerald Landau, courtesy the author.)

Gotham fills the background of this photograph of Pier 63 on Manhattan's West Side. B&O station carfloats loaded with freight cars are tied to the pier, which opened in 1958. The freight cars, including some refrigerator cars, were unloaded directly on the carfloat. Dock workers transferred the lading to the warehouse by hand. The B&O freight house at Twenty-sixth Street is the white building at far left. (Author.)

THE STATEN ISLAND RAPID TRANSIT RAILWAY COMPANY

PERTH AMBOY SUB-DIVISION

TIME TABLE

Effective 3.01 A. M.
OCTOBER 27, 1957.
(Subject to change without further notice.)

J. F. STEVENS
Superintendent
St. George, S. I.

W. J. FILEDORA
Traffic Agent
New York, N. Y.

P. K. PARTEE
General Manager

GENERAL OFFICE
25 BROADWAY, NEW YORK

NOTICE.

If Daylight Saving Time is inaugurated in New York in the Spring, The Staten Island Rapid Transit Railway trains will operate on Daylight Saving Time during the period it is in effect. During the balance of the year trains will operate on Eastern Standard Time.

10m. 11-57.

CROSS GOETHAL'S BRIDGE
TO ELIZABETH

The Easy Way
TO BALTIMORE, WASHINGTON AND THE WEST

FOR STATEN ISLANDERS the convenient route to Baltimore, Washington and the West is via the Baltimore & Ohio. Just across Goethal's Bridge is Elizabeth. Here you may board a fine B & O train for Baltimore, Washington, Pittsburgh, Chicago, Cincinnati, Louisville, St. Louis and other points in the West.

B & O FEATURE TRAINS

ROYAL BLUE and **COLUMBIAN** to Baltimore and Washington. Diesel-power and Streamlined.

CAPITOL LIMITED* and **SHENANDOAH†** to Pittsburgh and Chicago. Diesel-power between Washington and the West.

*Streamlined. †Stewardess-Nurse Service.

NATIONAL LIMITED (Stewardess-Nurse Service) to Cincinnati, Louisville and St. Louis. Diesel-power and Streamlined between Washington and the West.

No need to go all the way into New York to take your train, as all B & O trains stop at Elizabeth. It's the easy way—saves time, too.

For details of service, telephone:
New York, Murray Hill 3-4400; Elizabeth 2-9081

BALTIMORE & OHIO

This SIRT timetable from October 27, 1957, gives insight into how the B&O marketed its premium passenger trains to Staten Island commuters. In April 1958, the B&O discontinued all passenger service to Jersey City. (Author.)

Three
ARLINGTON YARD AND PORT IVORY

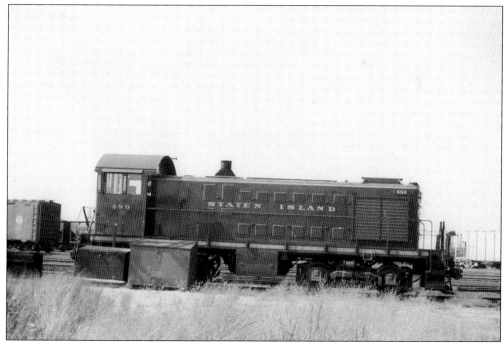

Arlington Yard was the first stop on Staten Island for freight trains coming from New Jersey. Alco S-2 No. 489, one of eight such locomotives assigned to the island, idles in the yard in the late 1940s. (Author.)

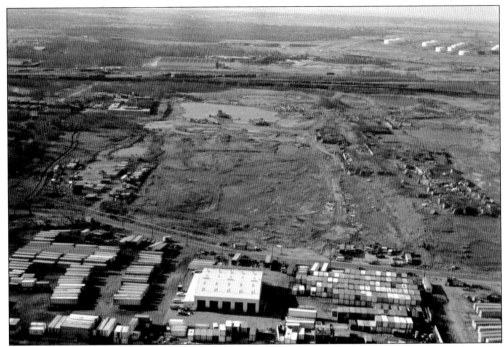

This March 1972 photograph gives an overall look at the location of the yard. The Arthur Kill and New Jersey are to the right, and the North Shore Subdivision tracks continue to the left. The remains of the Milliken Steel Mill, which closed its doors in 1914, are visible in the empty lot in the foreground. It was the only steel mill within New York City. (Photograph by Thomas R. Flagg.)

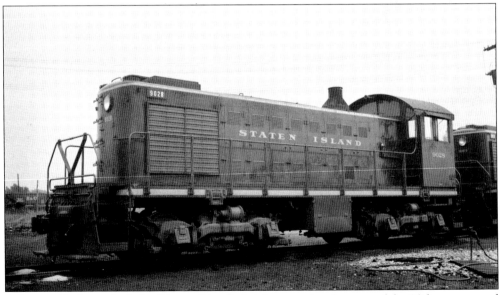

Arlington Yard was the hub of Staten Island's freight operation for most of the 20th century and a good place to photograph the SIRT's diesel roster. The B&O began a system-wide locomotive renumbering and reclassification program in 1956. Alco No. 9028 was reclassified as SA-3. It was delivered in 1943 as switcher class DS-5a and carried No. 484. (David Keller.)

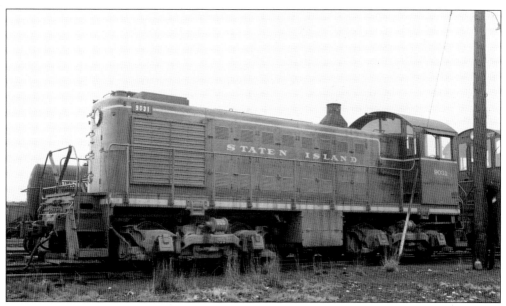

On June 2, 1957, Alco S-2 No. 9031 idles at Arlington Yard. It seems like this unit got some fancy striping when it was repainted earlier in the year. It originally carried No. 487. (David Keller.)

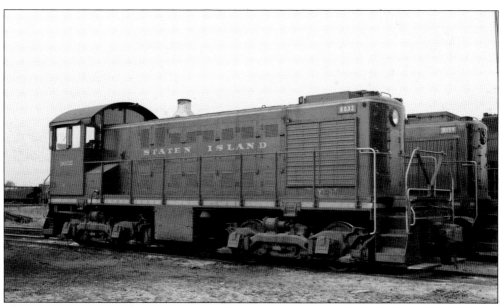

All of the original Alco locomotives delivered to Staten Island arrived with horizontal radiator shutters. No. 9032, pictured here on January 1, 1965, was delivered in June 1944 as unit 488. B&O Alco S-4 No. 9011 is on the sanding track behind it. (David Keller.)

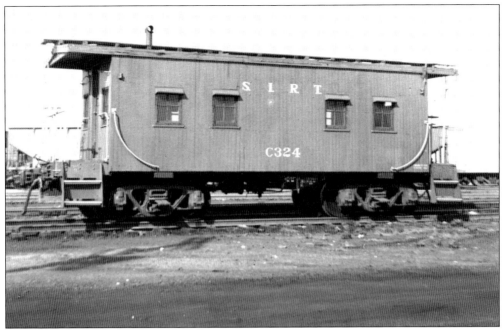

Caboose C324 is a former B&O I-1 class caboose modified for transfer service. It was common practice to remove the worn and rotting center cupola. Once assigned to the SIRT, these cars never left the island. Here, it awaits its next assignment at Arlington Yard in 1960. (H. Gerald McDonald.)

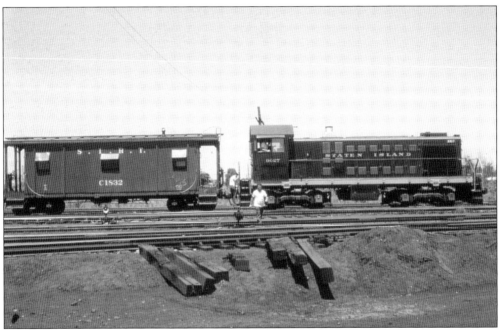

Caboose C1832 is being placed onto the end of a freight train at Arlington by Alco switcher No. 9027 in the summer of 1965. The caboose is another example of a former B&O hack modified for transfer service on the island. This I-13 class car had its bay windows removed so it could clear the high-level platforms at SIRT passenger stations. (Robert A. Miller.)

On November 25, 1948, the American Freedom Train, which was on a national tour, stopped on Staten Island. Donald W. Spiro of New Springville (pictured) went to visit the special train with his brother, Richard. Over 10,000 people came to Arlington to see the converted passenger train. Each car carried an exhibit dedicated to US history. (Don Spiro.)

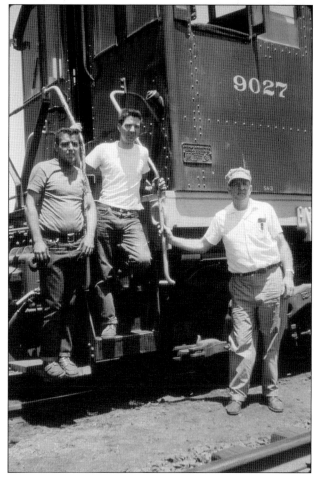

The proud and friendly road crew of Alco S-2 No. 9027 takes a break on the cab steps of the engine as the men await their next assignment on a hot summer day in 1965. (Robert A. Miller.)

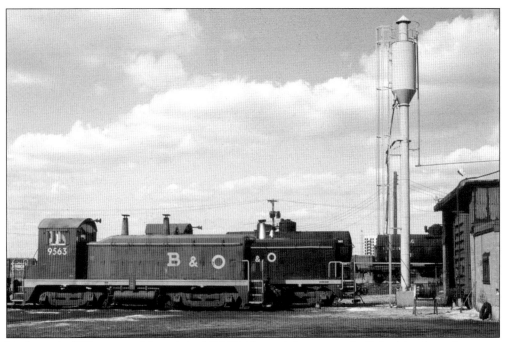

By the early 1970s, most of the original SIRT Alco switchers moved off the island to other parts of the B&O system. Electro-Motive Division NW2 switchers, such as No. 9563 (pictured), became the main freight power for the island. This superb composition from March 1, 1975, gives a good look at the sanding tower and fueling facility. (Thomas J. Nemeth.)

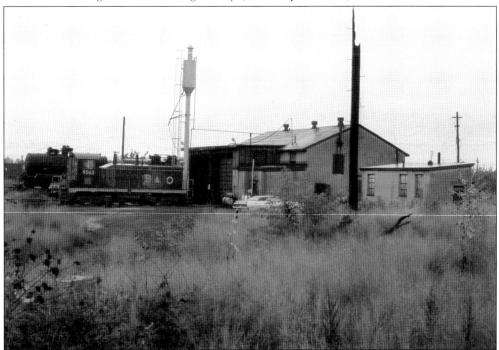

The engine house at Arlington was a small, two-stall, cinder-block building. The tank car in the background was used for fueling locomotives. (Don Spiro.)

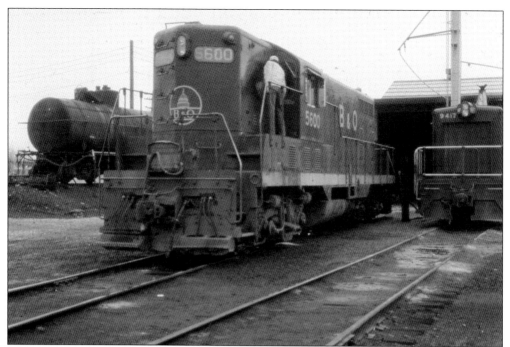

Baltimore & Ohio GP7 No. 5600 was on the fueling track at the Arlington engine house in April 1976. Geeps became common visitors to the island when the B&O began rotating power from East Yard in Philadelphia. (Tom Griffiths.)

In April 1976, a B&O I-12 caboose in the blue and yellow pool service scheme was spotted in front of the car department at Arlington. Materials used to perform minor repairs to freight cars were stored inside. (Tom Griffiths.)

This close-up photograph of B&O fuel car No. X421 provides a good look at the pumping mechanism that was attached to the car's dome. It was spotted at the Arlington engine house in April 1976. (Tom Griffiths.)

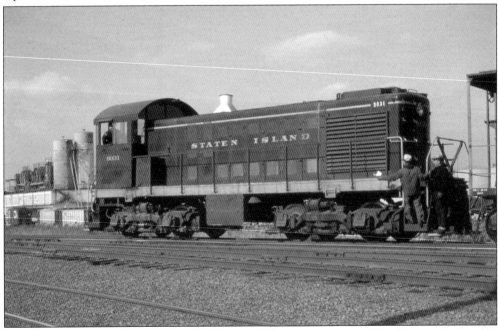

In 1966, Alco switcher No. 9031 pulls a covered hopper car toward the Procter & Gamble manufacturing plant at Port Ivory. The plant was the B&O's largest customer on the island. Ivory soap and Duncan Hines cake mixes were its most famous products. (Photograph by Gerald Landau, courtesy the author.)

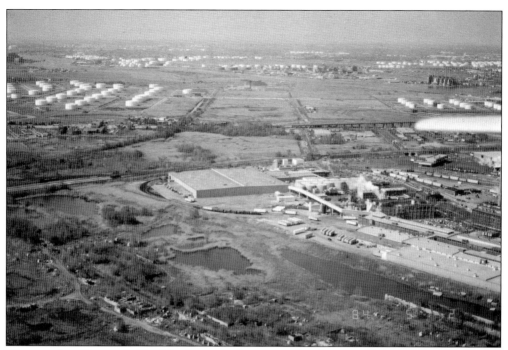

The sprawling Procter & Gamble plant, which occupies Port Ivory and Howland Hook, is visible at right in this aerial photograph from 1972. Western Avenue bisects the plant. Covered hoppers fill the main receiving yard. (Thomas R. Flagg.)

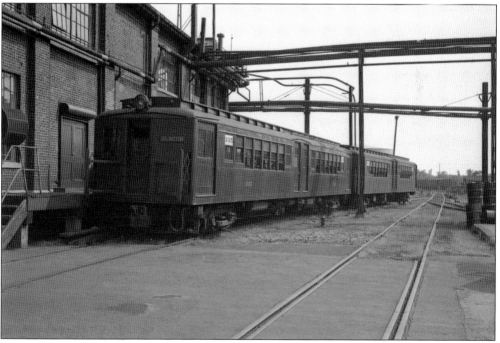

In 1925, as a safety precaution, a section of track was electrified from Arlington Station to Port Ivory. Procter & Gamble employees, who commuted to work on the SIRT, could take the train all the way to factory property. This service lasted until 1948. (Edward F. Bommer.)

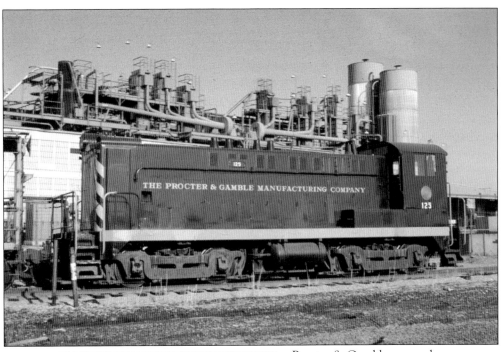

Procter & Gamble was such a busy place that cars were moved and spotted by a company-owned switcher engine. Baldwin VO660 No. 125 is on duty here in December 1965. A medallion depicting P&G's moon-and-stars logo is attached to the cab. (Thomas J. Nemeth.)

Howland Hook was also the site of a B&O coal dumper, completed in 1949. The facility had a capacity of 100 cars per eight-hour shift. The dumped coal was delivered via barges to utilities in the harbor. It was in the process of being dismantled by the time of this summer 1965 photograph. (Robert A. Miller.)

Four
THE TRAVIS BRANCH

In the 1930s, a branch line was constructed south from Arlington Yard into the marshes of the island's western shore. It was built to serve the recently constructed Gulf Oil refinery. This wood trestle carried the single track over Old Place Creek. (Robert A. Miller.)

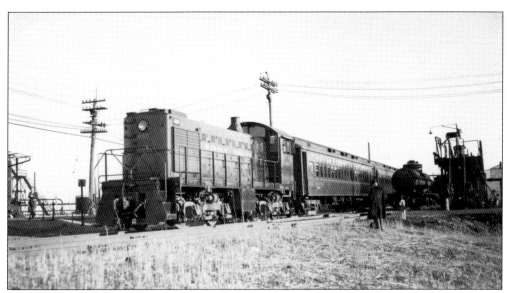

On April 9, 1949, the Joint Railfan Trip Committee ran a special train into the Gulport refinery. Locomotive No. 485 pauses for a photograph on a siding inside the complex. The small yard on the property had a capacity for 150 tank cars. (Edward F. Bommer.)

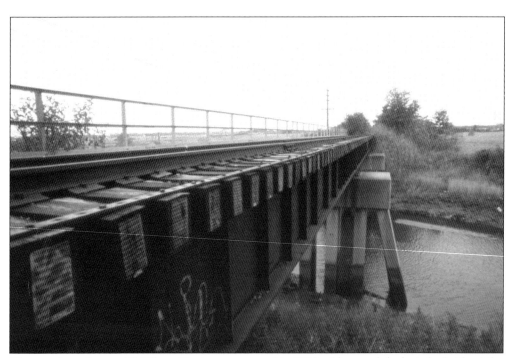

The wood trestle over Old Place Creek was replaced in 1966 with a steel-deck girder bridge. The new span featured concrete piers and components from US Steel. In 1957, the line was extended to Travis to serve the newly built Consolidated Edison power plant. (Author.)

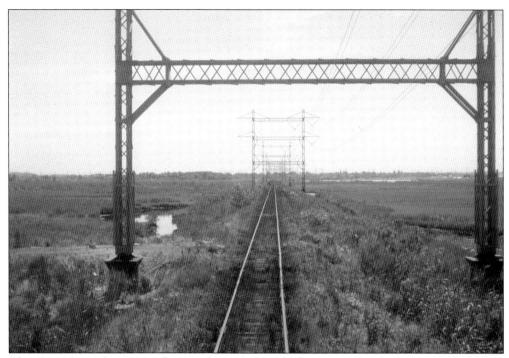

The Travis Branch was mostly a single-track line all the way to South Avenue. It looks like weeds were recently burned on the right-of-way in this summer 1965 view of the line. (Robert A. Miller.)

The exhaust stack of Alco S-2 No. 9027 fills the frame in this dramatic engineer's view of the Travis Branch in summer 1965. The Goethals Bridge and Arthur Kill Vertical Lift Bridge are both visible in the distance. (Robert A. Miller.)

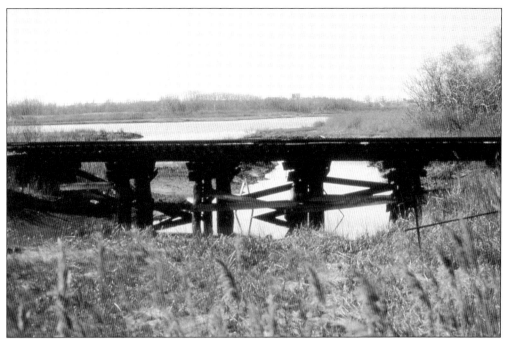

The B&O built wood trestles to carry the track over the many creeks that dissect the right-of-way to Travis. This small bridge was photographed at Prall's Creek. (Author.)

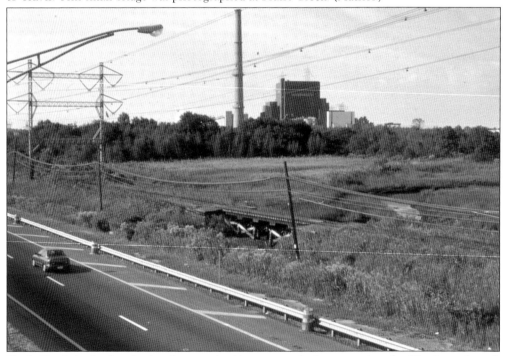

Neck Creek is the last body of water the line crosses before entering the Travis coal yard. This view from the Meredith Avenue overpass shows the wood trestle and how close the line runs to the West Shore Expressway. The Consolidated Edison power plant is visible in the background. (Author.)

In the early 1980s, the power plant changed to barge-delivered coal shipments. The Travis branch was abandoned and used for rolling-stock storage. This six-track yard once held coal hoppers. In 1988, Whitcomb center-cab diesel No. 9 and three multiple-unit electric cars were being stored here for the New York Trolley Museum. (Gaspar Pitanza.)

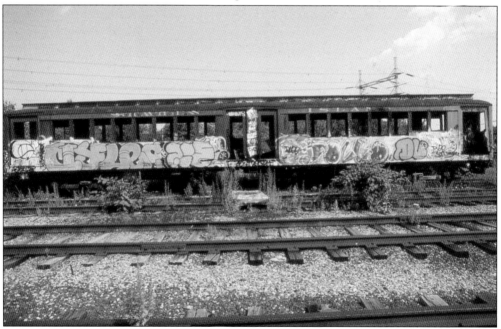

In 1990, the Whitcomb diesel and two of the cars were moved to the trolley museum's new home in Kingston, New York. Car No. 353, deemed too damaged to move, remained a resident of Travis Yard until 2003, when it was scrapped in the revitalization of Travis Yard. In July 2002, the car was photographed with no windows and covered in graffiti. (Author.)

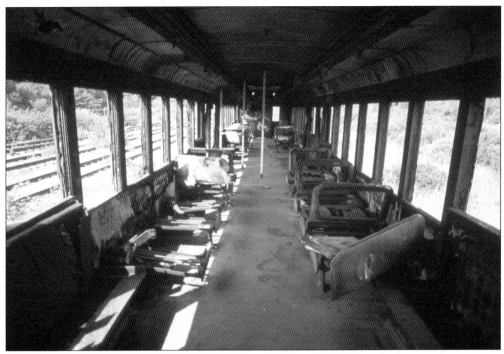

The interior of multiple-unit electric car No. 353 was ravaged by the weather, vandals, and time. There is almost nothing left of the rattan seats in this July 2002 photograph. (Author.)

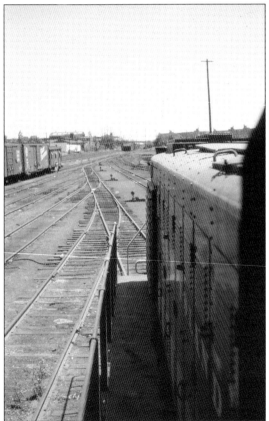

Alco S-2 No. 9027 enters Arlington Yard after pulling two bad-order hopper cars from Travis Yard in summer 1965. The locomotive is rolling toward the North Shore Subdivision. The South Avenue overpass is visible in the distance. (Robert A. Miller.)

Five
NORTH SHORE SUBDIVISION

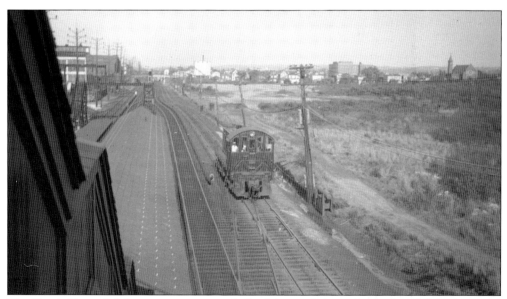

The North Shore Subdivision encompassed all of the track from the Arthur Kill Bridge to St. George Yard. In this east-facing view, SIRT Alco S-2 No. 489 runs light into Arlington Yard in 1946. The roof of the Arlington passenger station is visible at left. (Photograph by Stephen Bogart, courtesy David Keller.)

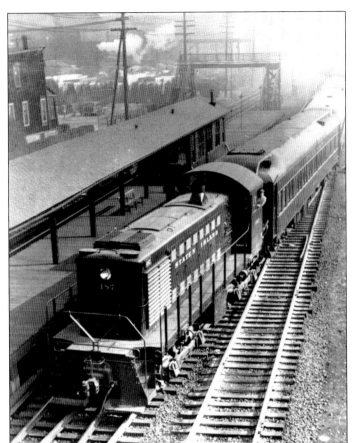

The SIRT handled many troop trains during World War II and the Korean War. Alco S-2 No. 487, void of fancy striping, pulls a string of Pullmans toward Arlington Yard. The bustling industry beyond the footbridge at left is the Bethlehem Steel Propeller Plant. Metal used to fabricate ship propellers was shipped in by rail and stored outdoors. (James Mischke.)

Multiple-unit car No. 329 handled the last passenger run on March 31, 1953. Arlington Station was closed the next day. (David Pirmann.)

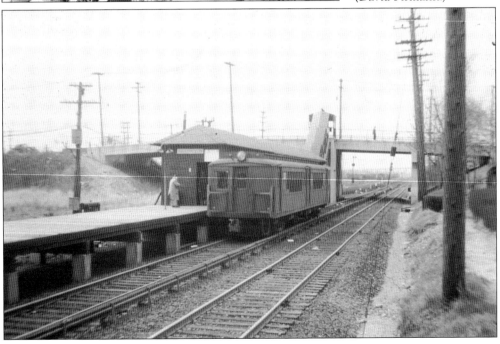

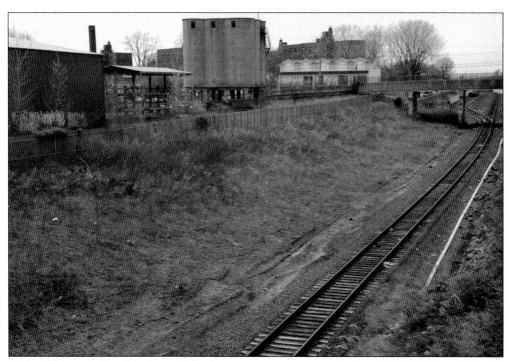

Arthur Dreyer & Son Lumber and Fuel was a small, rail-served industry near Harbor Road Station. It had two sidings on the property, one for lumber and one for coal deliveries. The concrete coal silos and lumber rack are visible on the left. (Author.)

In 1946, a St. George–bound multiple-unit car leaves Mariner's Harbor. The telltale near the Simonson Avenue overpass warned brakemen riding on the top of freight cars that a low overhead obstruction was coming up. Lake Avenue is the next stop in the distance. (Photograph by W.J. Edwards, courtesy David Keller.)

Near Lake Avenue Station, a cluster of small industries appears. The cinder-block silos of the Fiore Brothers Coal Company are visible at left. The Arlington-bound track was removed in 1957. (Gaspar Pitanza.)

The Wallerstein Corporation, a syrup manufacturer, was a major customer on the North Shore Subdivision. Bosco chocolate syrup was its most famous product. Wallerstein also specialized in making synthetic enzymes. The factory spur veers off to the left in this view from Granite Avenue. (Gaspar Pitanza.)

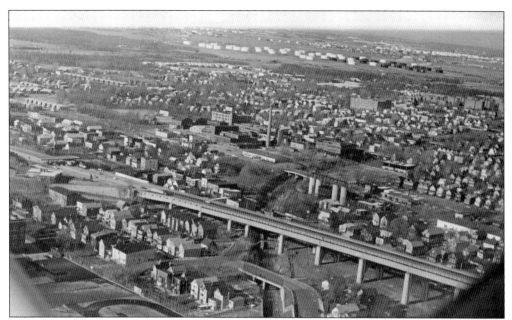

In this superior aerial photograph of Elm Park, the large Wallerstein complex and its many buildings are at center. The North Shore Subdivision track veers to the right toward Mariners Harbor. The Elm Park passenger station is nestled under the Bayonne Bridge approach. (Thomas R. Flagg.)

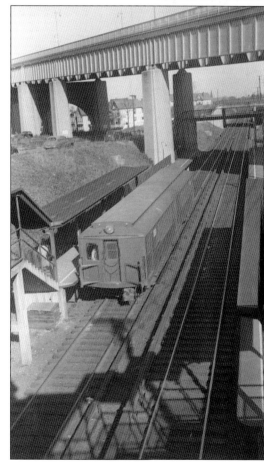

In this 1950 photograph with a view looking east, a single car pauses at the Elm Park Station. The train is bound for Arlington. The Bayonne Bridge approach looms in the background. (Photograph by W.J. Edwards, courtesy David Keller.)

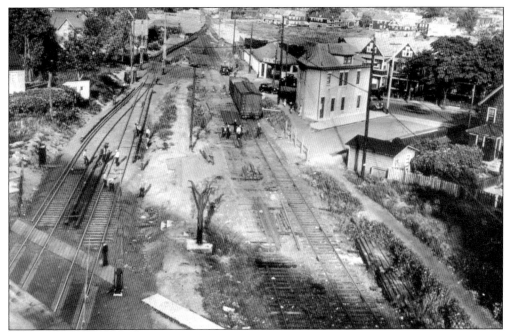

Grade-crossing elimination work is under way at Elm Park in the early 1930s. A shoo-fly track is being installed, and the right-of-way would be dropped into a cut below grade. The Hi-Jed coal dealership (top right) has two open hopper cars in the siding. (Photograph by William J. Madden, courtesy the author.)

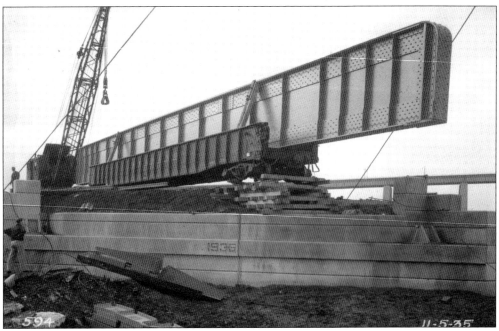

After Elm Park, the North Shore Subdivision was raised above grade. On November 5, 1935, the south girder for the bridge over Nicholas Avenue was delivered in a 65-foot Reading Railroad gondola. The ends of the car were dropped to accommodate the 80-foot girder. (Michael Saitta.)

Tower Hill Station (pictured) and Port Richmond Station were raised onto a unique concrete trestle in 1935. A path under the trestle allowed pedestrians to walk between stations. (Author.)

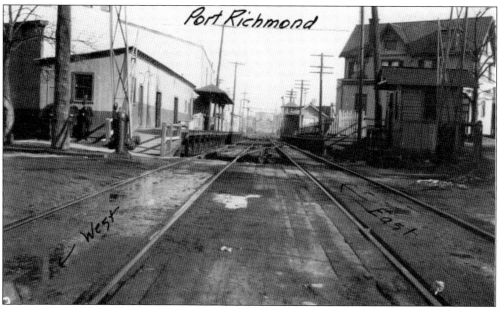

Port Richmond Station was once at-grade, as this 1911 photograph shows. The right-of-way is flanked on both sides by wood high-level platforms, common in commuter operations. (B&O Railroad Historical Society.)

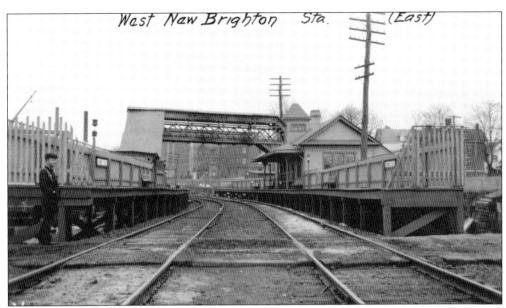

West New Brighton Station is seen in this east-facing view from 1911. The main building is accented with elegant Victorian details. (B&O Railroad Historical Society.)

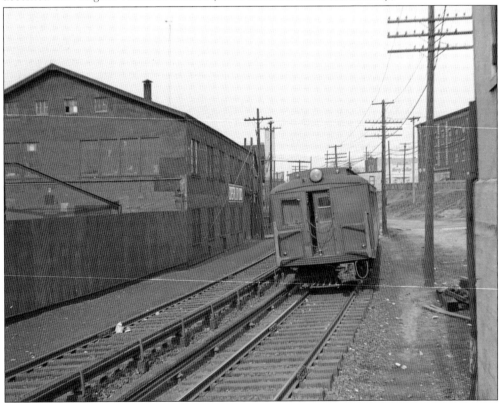

In the early 1950s, not long before the line became bereft of passenger service, a train bound for St. George leaves the West New Brighton Station. The building at left belongs to the Coastal Dry Dock. (Author.)

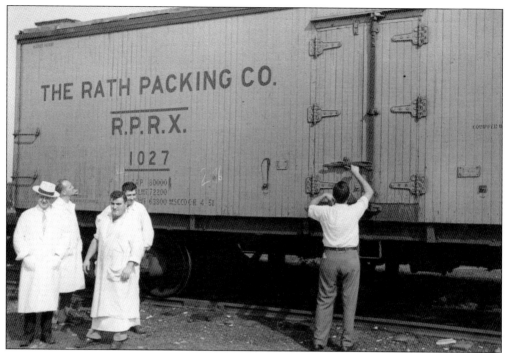

A Rath Packing Company refrigerator car has just arrived at the West Brighton team track. Richard Spiro is breaking the seal on the door of the car, which is loaded with fresh meat from Chicago. Edward Spiro (in hat), owner of the Capitol Market in Port Richmond, waits with employees (from left to right) Anthony and Rocco Remo and Bill Braisted. In 1951, the team track could handle 82 freight cars. (Don Spiro.)

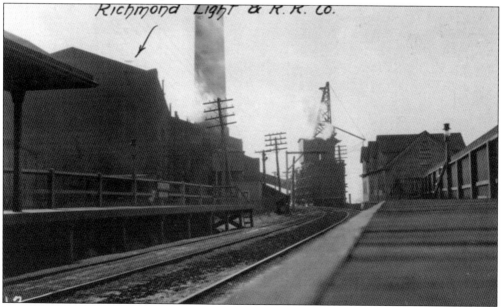

In 1911, Livingston Station had wooden platforms and was flanked on either side by the haze of industry. The Richmond Light & Power Company (left) ran a trolley line on the island. (B&O Railroad Historical Society.)

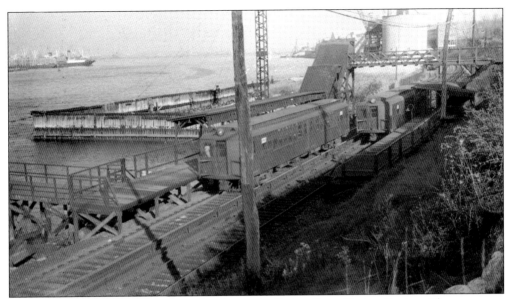

In 1947, two single-car trains pass each other at the Sailors Snug Harbor Station. The enormous US Gypsum factory towers over the track in the background. (Photograph by W.J. Edwards, courtesy David Keller.)

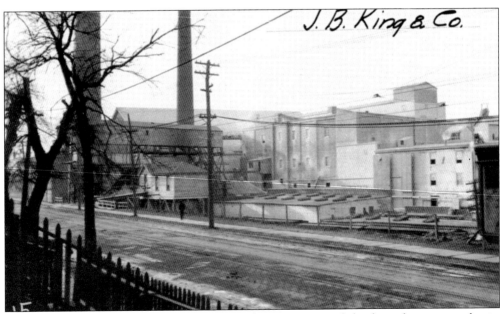

In 1911, J.B. King & Company, a plaster manufacturer, occupied this huge factory complex in New Brighton. (B&O Railroad Historical Society.)

The factory was later purchased by the US Gypsum Company, which produced Sheetrock that was distributed by ship and rail across the Northeast. The industrial valley surrounding the tracks is quite visible in this aerial photograph. (Thomas R. Flagg.)

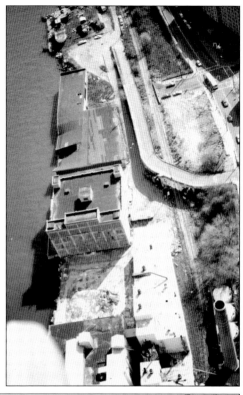

The Jersey Street grade crossing is seen in 1911. St. George Yard is to the right. (Brian Merlis.)

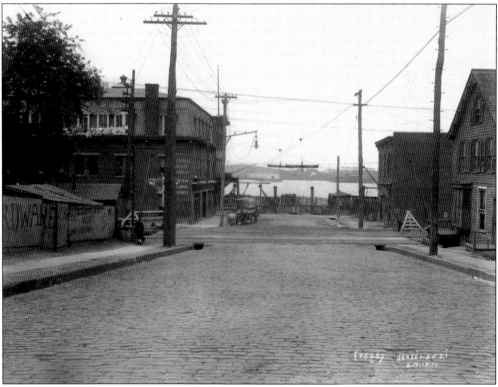

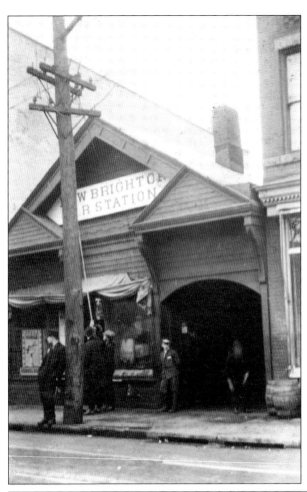

This wooden structure nestled between two brick buildings at the base of Westervelt Avenue is the street-level entrance for the New Brighton Station at the time. (Author.)

This 1911 photograph gives a good view of the pedestrian bridge that carried travelers from street level to the tracks below. New Brighton was the last station on the North Shore Subdivision before St. George Yard. (B&O Railroad Historical Society.)

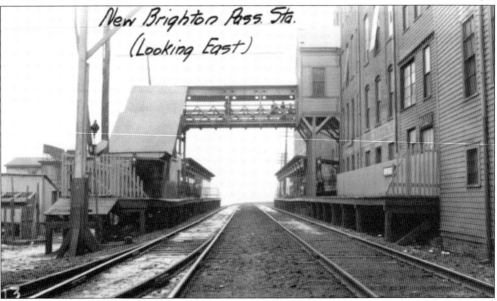

Six
ST. GEORGE YARD AND WATERFRONT TERMINAL

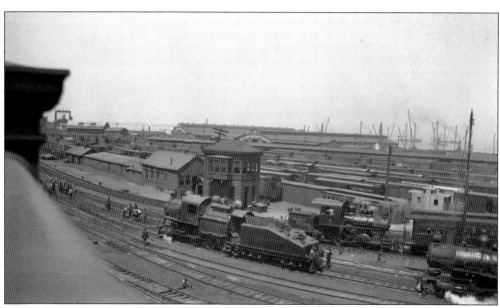

St. George Yard was where B&O placed its main waterfront terminal in New York City. The strategic location allowed the railroad to interchange, via carfloat, with other terminals across the harbor. In this 1921 photograph, a B&O Class D-23 Camelback locomotive passes SIRT No. 8, a Forney type, in front of Tower A. (Photograph by James V. Osborne, courtesy David Keller.)

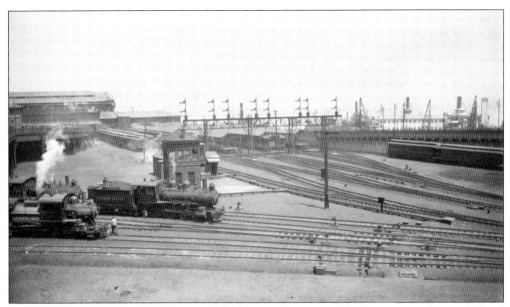

This is an excellent view of the passenger platforms at St. George. The ferry terminal looms behind the locomotives. B&O No. 1347, a B-8 class 4-6-0 type locomotive, and SIRT No. 25 pause at tower B in 1921. (Photograph by James V. Osborne, courtesy David Keller.)

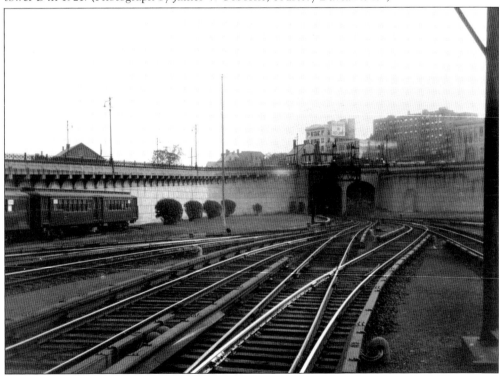

The west face of the St. George Tunnel was built in 1884 and lengthened in 1905. The second portal was for the proposed SIRT subway link to the BMT line in Brooklyn, but it was never completed. At left in this 1927 photograph are two new electric multiple-unit cars. (Photograph by Harry S. Brown/Bob's Photos, courtesy Edward F. Bommer.)

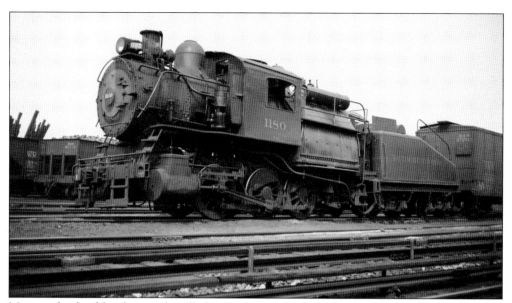

Many carloads of freight were handled at St. George Yard. In this view from July 28 1933, B&O No. 1180, a D-23 class camelback with Wooten firebox, pulls a freight train out of the yard. The SIRT electrified its passenger service in 1925. Steam locomotives handled the freight until 1946. (Photograph by W. Wyckoff, courtesy David Keller.)

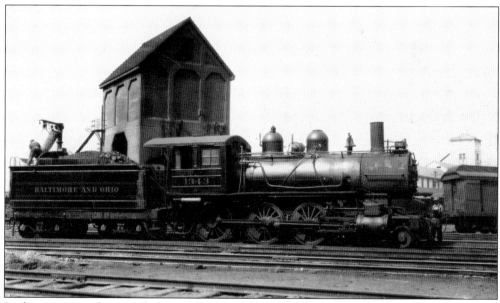

In this stunning photograph from August 9, 1924, B&O No. 1343, a class B-8, poses in front of the concrete coaling tower in the yard. The locomotive is one of several sent to Staten Island in the 1920s to assist with growing passenger service. (Photograph by Bruce D. Fales, courtesy Edward F. Bommer.)

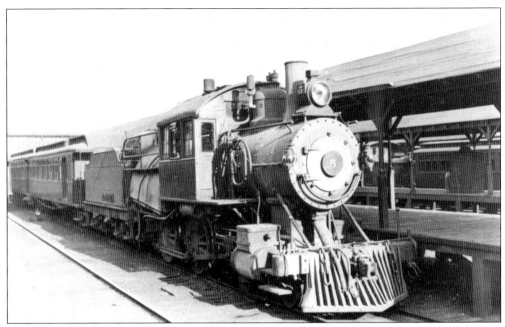

The engineer peeks out from the cab of SIRT No. 5, a Class J camelback built by Baldwin in 1886. The short passenger train, made up of a Wason coach and combine, prepares to leave for Tottenville in December 1919. (T.F. Gleichmann and K.F.L. Grosche.)

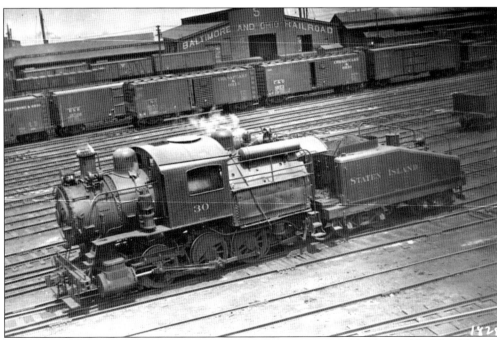

SIRT Camelback No. 30 pauses in front of Pier 5 at St. George in the late 1930s. The Class D locomotive was built by Alco's Rhode Island Works in 1908. (Edward F. Bommer.)

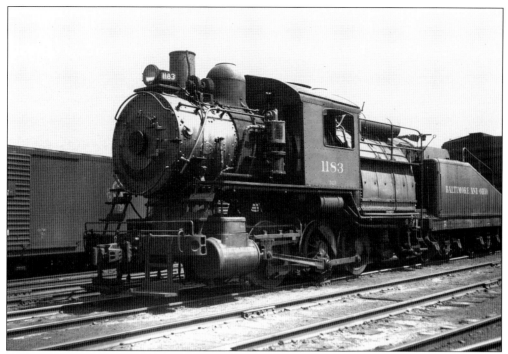

In this roster photograph, B&O No. 1183 pauses with a freight at St. George on August 29, 1945. It is one of five locomotives specifically built by the B&O for Staten Island service. (Bob's Photos, courtesy Edward F. Bommer.)

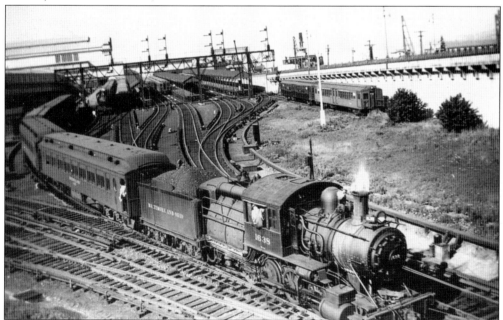

This photograph shows the special train that operated on Sundays to the Mount Loretto Home for Orphans and Wayward Children in Pleasant Plains. On June 19, 1938, a 50th-anniversary memorial was held for Father John Drumgoole, founder of the home. This is one of the two special runs that day. (George Conrad.)

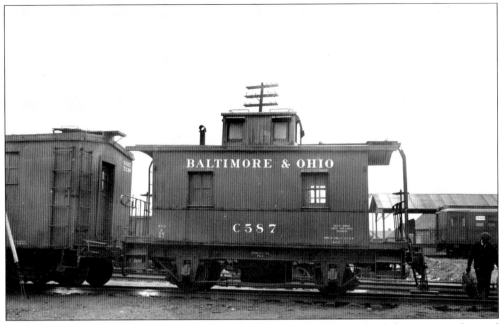

The B&O Class K-1 caboose, once the railroad's standard four-wheel design, was deemed inappropriate for interchange by the 1930s and found its way to the terminals on Staten Island. Spotted next to a tool car in St. George, K-1 C587 awaits it next assignment. (Bob's Photos, courtesy Edward F. Bommer.)

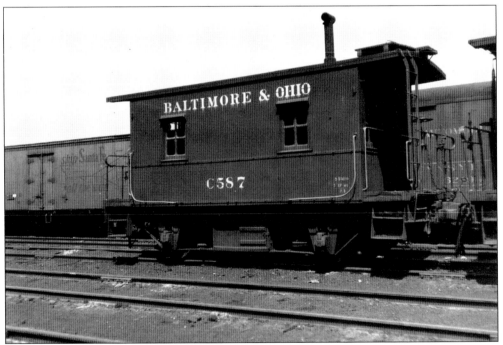

Caboose C587 had its cupola removed when it was repainted in the 1940s. The cupolas were prone to rot, and their removal extended the lives of the cars. Photographed on August 29, 1945, this caboose was not scrapped until 1953. (Bob's Photos, courtesy Edward F. Bommer.)

Stephen Bogart snapped this excellent photograph during a railroad event at St. George Yard. The concrete coaling tower and water columns of the steam engine servicing facility were still active in 1946. (David Keller.)

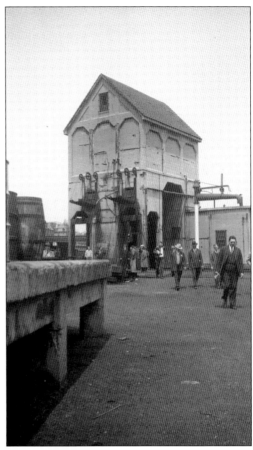

Several electric multiple-unit cars are on the St. George layup track on January 26, 1934. The main body tracks in the background are filled with freight cars. The Million Dollar retaining wall, built in 1890 and still standing today, is visible at left. (Bob's Photos, courtesy Edward F. Bommer.)

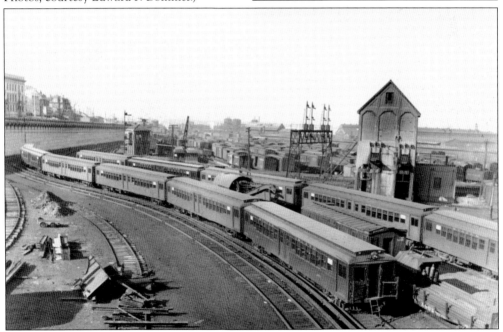

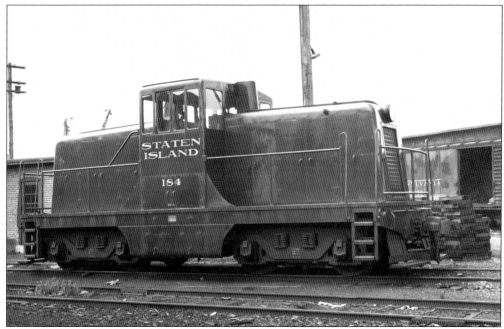

The first diesel arrived on Staten Island in 1943. The 65-ton, 400-horsepower center cab switcher from General Electric was designated No. 184. It is seen at St. George on July 24, 1948. (Railroad Avenue Enterprises.)

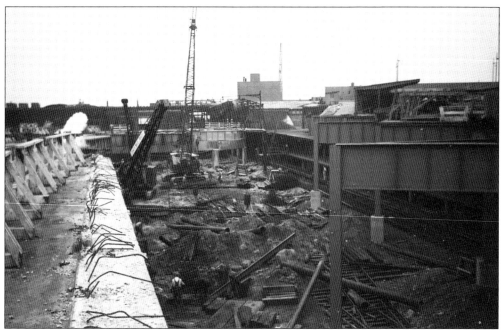

On June 24, 1946, the St. George Ferry Terminal was destroyed in a nine-alarm fire. The terminal had to be completely rebuilt over the next four years. Seen here in the late 1940s, construction takes place over partially buried tracks. (Photograph by Charles Houser, courtesy the author.)

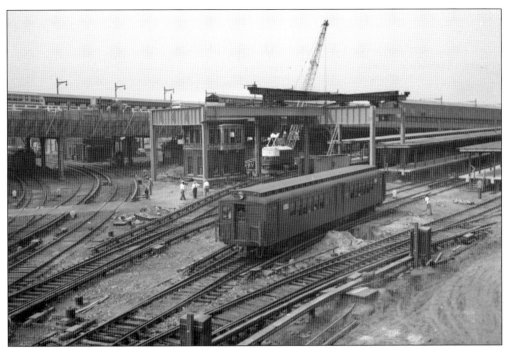

A single electric car leaves the passenger station in 1948. Construction to rebuild the terminal is under way in the background. (Photograph by Charles Houser, courtesy Edward F. Bommer.)

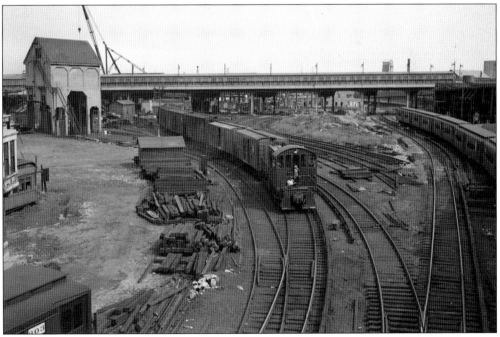

A short freight train gingerly plies the rails as it snakes its way through the ferry terminal construction site in 1948. (Photograph by Charles Houser, courtesy Edward F. Bommer.)

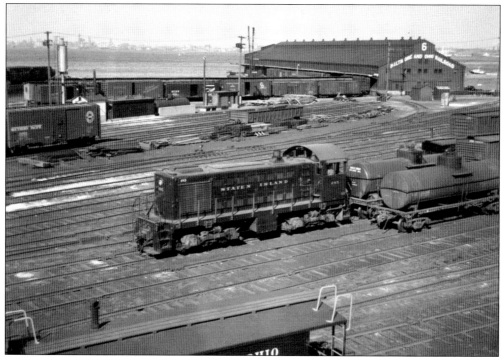

Alco locomotive No. 485, still in its simplified wartime paint scheme, prepares to pull a freight out of St. George Yard on May 3, 1952. Dulux gold striping will be added when the unit is repainted. Transfer caboose C648 stands in the foreground. (Photograph by W.V. Faxon Jr., courtesy David Keller.)

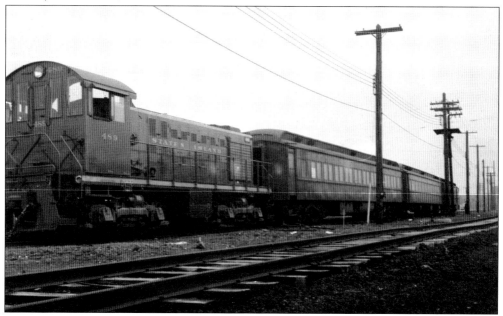

The Baltimore & Ohio Railroad accounting department made an inspection trip of the Staten Island facilities on October 22, 1995. The train seen here pulling out of St. George is made up of Alco S-2 No. 489 and B&O coaches. (Edward F. Bommer.)

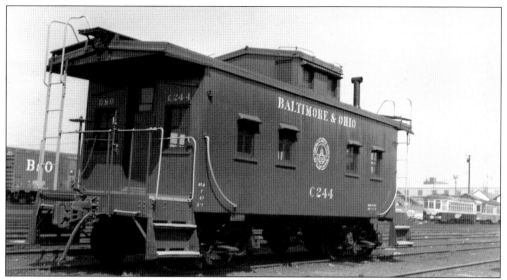

This Class I-1 caboose replaced the old 1890s four-wheel cabooses in the mid-1950s. On the track in the background, trolley cars are being stored for the New York Trolley Museum. (Bob's Photos, courtesy Edward F. Bommer.)

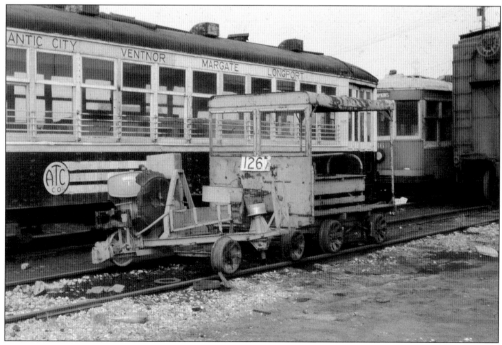

In 1966, track speeder No. 1267 was spotted in front of an old Atlantic City trolley car being preserved by the New York Trolley Museum. (Robert A. Miller.)

In December 1965, this neon sign located inside the ferry terminal invites passengers to "Ride the Rapid." The train station platforms are located at the bottom of the short staircase. (Robert A. Miller.)

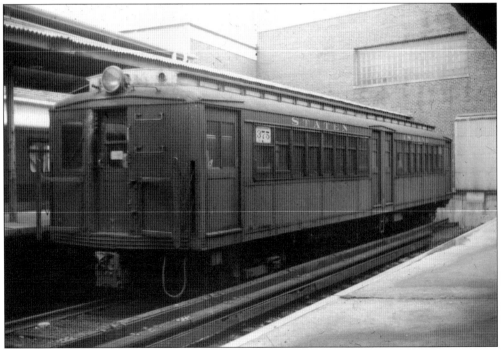

Multiple-unit electric car No. 375 is pictured here at the St. George passenger terminal platforms. (Author.)

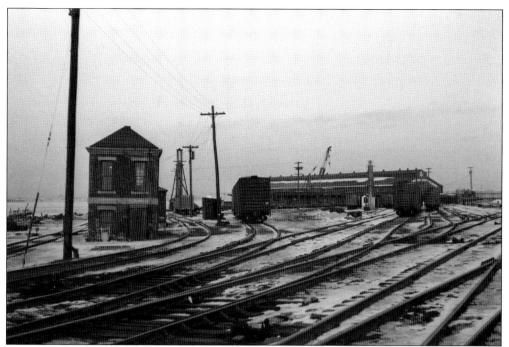

The brick structure at left in this 1962 photograph is the B&O yard office at St. George. It processed all the cars being floated onto and off the island. (Robert A. Miller.)

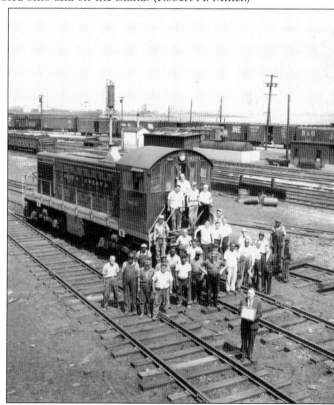

Yard workers and two members of the SIRT management team pose for this June 1966 photograph. It appears that a safety award was proudly presented to the employees that day. (Chesapeake & Ohio Railroad Historical Society collection, CSPR 11642.CN4.)

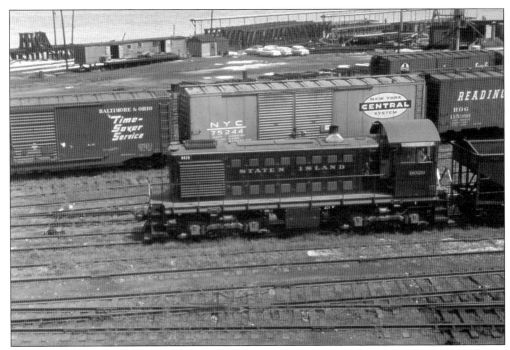

In September 1969, SIRT Alco S-2 No. 9029 shunts freight cars in the yard. In the late 1960s, longer, 50-foot boxcars became quite common. The Howe truss–style float bridge and several empty carfloats are visible in background. (Edward F. Bommer.)

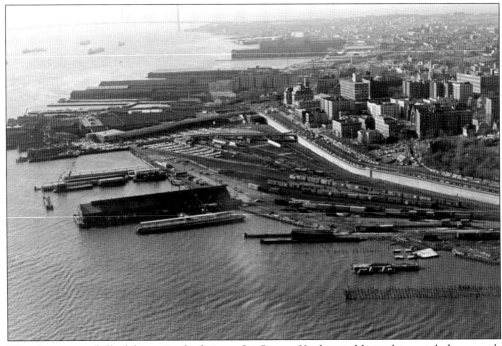

The placement of all of the major facilities at St. George Yard is visible in this aerial photograph from March 1972. The large building that extends into the bay at center is Pier 6. (Thomas R. Flagg.)

The New York City Transit Authority took over passenger service on Staten Island in 1972. Long Island Rail Road MP-72 passenger cars were experimented with on the island lines. Here, three cars await passengers at a platform in the St. George Terminal. (Edward F. Bommer.)

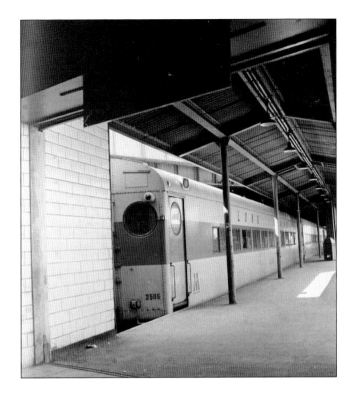

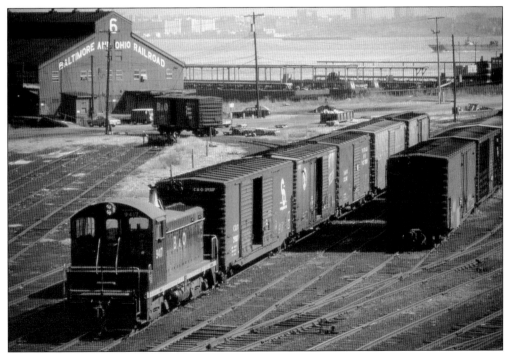

In the early 1970s, the B&O began moving the Alco S-2 locomotives off the island. General Motors Electro-Motive Division switchers lettered for the B&O became the common power for freight trains. In March 1976, SW900 No. 9417 switches cars in front of Pier 6. (Tom Griffiths.)

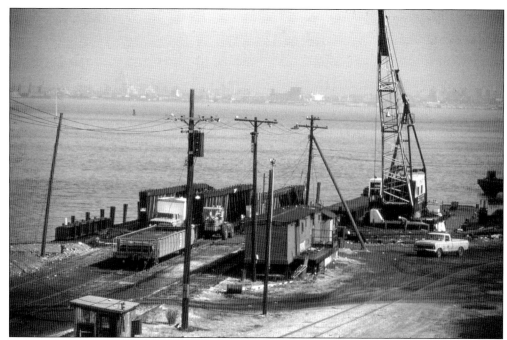

In 1976, only one float bridge remained at St. George. Freight cars were transferred to carfloats and floated to other terminals in New York Harbor. Staten Island Railroad Corporation reach car X1 is visible in front of the bridge. B&O marine crane No. 208 is at right of the bridge. (Tom Griffiths.)

The Howe truss–style float bridge at St. George could handle two- and three-track carfloats. Loaded B&O station carfloat No. 216, a two-track model, is being tied to the bridge in 1976. Switch points were integral to the design of float bridges. (Tom Griffiths.)

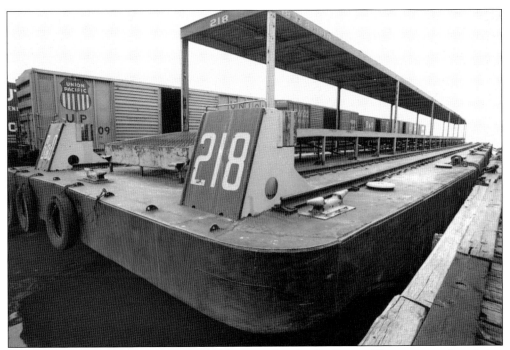

Empty carfloat No. 218 is tied up to a loaded float near Pier 6 at St. George. The station carfloat design allowed freight cars to be opened and unloaded while still on the float. (Gaspar Pitanza.)

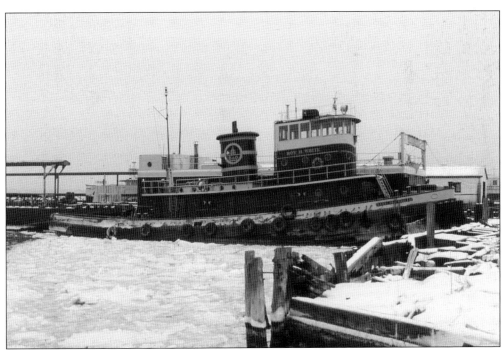

On an icy day in January 1976, B&O diesel tug *Roy B. White* is tied fast to the dock at St. George. The handsome livery was designed by Otto Kuhler in the early 1950s. (Author.)

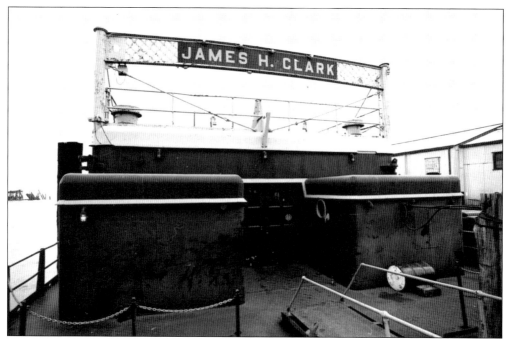

The *James H. Clark* was a floating machine shop used by the B&O Marine Department at St. George. (Gaspar Pitanza.)

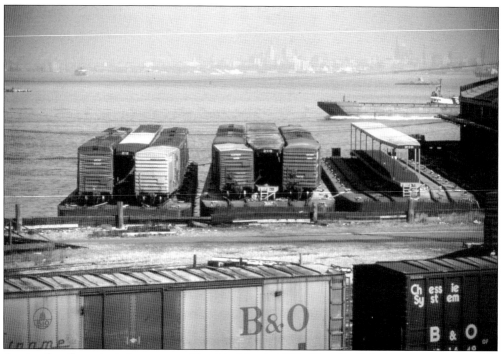

A trio of carfloats is tied up next to Pier 6 in March 1976. (Tom Griffiths.)

A carfloat waits to be unloaded at the float bridge in July 1976. (Tom Griffiths.)

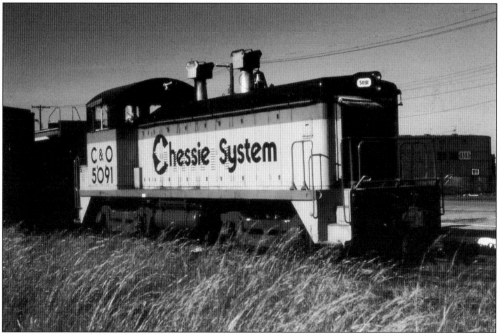

Carfloating ended at St. George in 1981. The last engine to serve the Staten Island Railroad Corporation was C&O SW9 No. 5091. It was photographed at St. George in March 1985, about one month before the unit was sold to the New York, Susquehanna & Western Railway. (Photograph by John Mech, courtesy the author.)

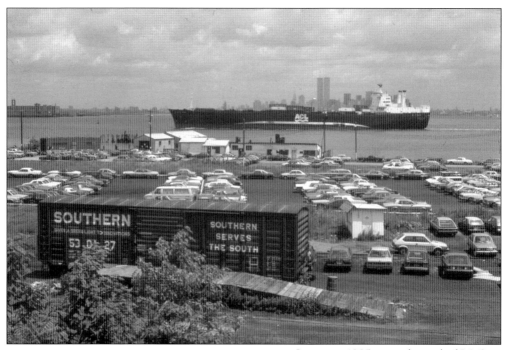

In spring 1985, near the end of B&O freight service on Staten Island, a single Southern boxcar is spotted at the team track in St. George Yard. By this late date, most of the freight yard has been claimed as a parking lot for ferry commuters. (Author.)

In summer 1988, a train comprising R-44 SI cars is laying up on the old North Shore Subdivision tracks. The R-44 SI cars were identical to R-44 cars used in other boroughs on subway lines, except that the Staten Island cars were built to Federal Railroad Administration standards. (Gaspar Pitanza.)

Seven
CLIFTON SHOPS AND THE LINE TO SOUTH BEACH

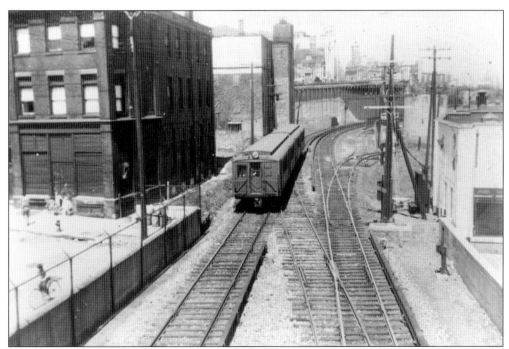

The East Shore Subdivision began at the St. George Tunnel portal. In this 1961 photograph, a Tottenville-bound train has just exited the tunnel. The spur tracks on the right belong to the American Dock Terminal Company. (Photograph by Harold A. Smith, courtesy Thomas R. Flagg.)

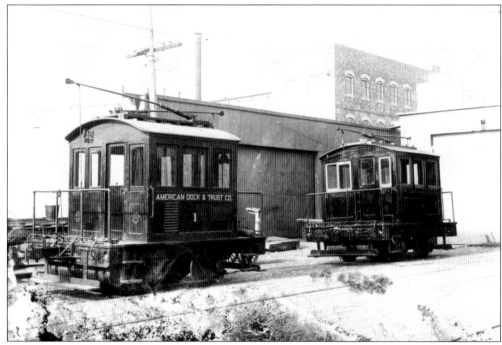

The American Dock Terminal Company employed a variety of electric box cab locomotives to move freight around the warehouse complex. The locomotives drew power from the trolley wire hung above the tracks. Locomotive No. 1 (left) was built in 1905. (Thomas R. Flagg.)

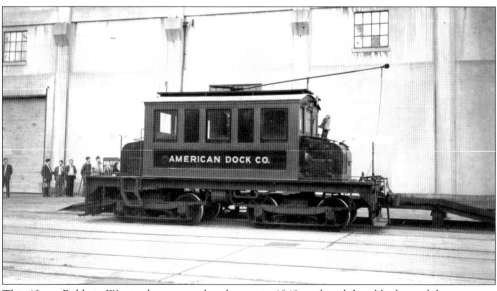

This 40-ton Baldwin-Westinghouse steeple cab, seen in 1948, replaced the older box cab locomotives in the late 1920s. (Edward F. Bommer.)

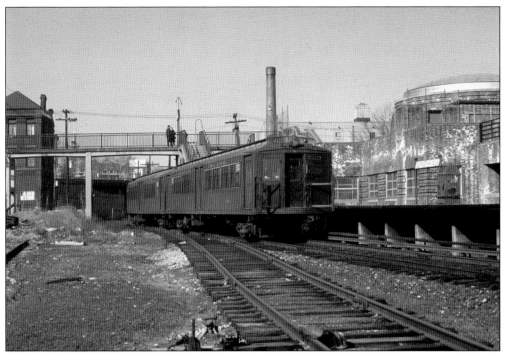

On February 28, 1970, a two-car Tottenville-bound train pauses at the Tompkinsville Station. The spur in the foreground leads to the team track. (Thomas J. Nemeth.)

Several freight cars are spotted at the Tompkinsville freight house and team track in 1965. It had a capacity of 65 cars. (Tom Griffiths.)

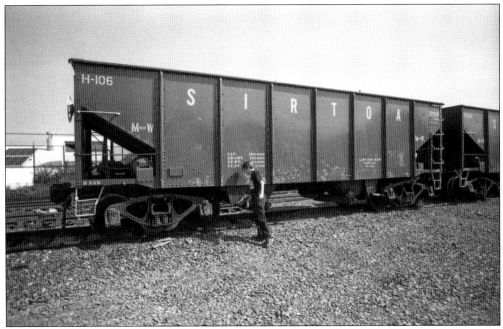

In the late 1970s, the team track was converted to a maintenance-of-way facility for the Staten Island Rapid Transit Operating Authority (SIRTOA). These freshly painted hoppers, used for ballast service, stand on a siding in the facility in 1988. (Gaspar Pitanza.)

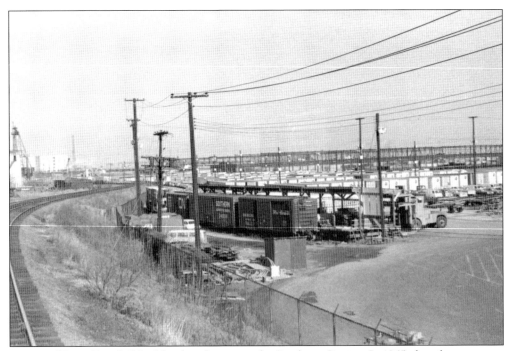

Municipal Piers 12 and 13 had freight sidings near the Stapleton Station. In 1965, three boxcars were spotted at the platform there. Containers fill the background of this photograph, foreshadowing the future of freight handling. (Tom Griffiths.)

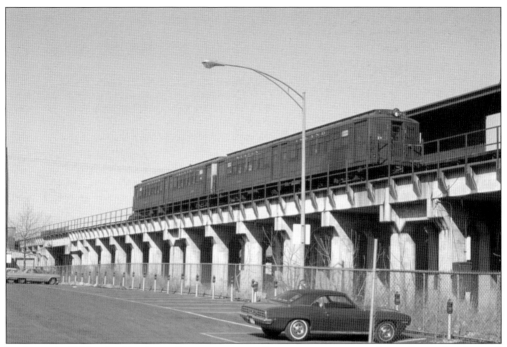

In the early 1930s, the Stapleton Station was raised onto a concrete trestle similar to the elevated trestle used on the island's North Shore. A two-car train led by MUE motor No. 348 pauses at the island-type platform in February 1970. (Thomas J. Nemeth.)

A Tottenville-bound train approaches Clifton Station in 1962. The Clifton freight house and team track is at left just behind the train. The tracks at right lead to the Clifton Shops. (Robert A. Miller.)

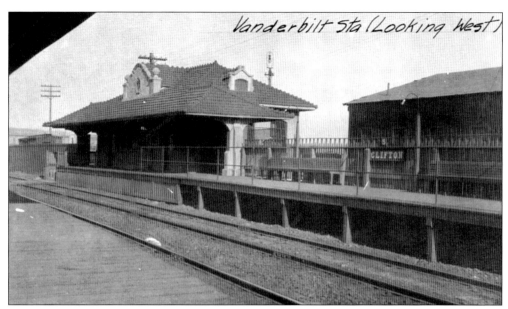

The area known as Clifton was once the northern terminus for the original Staten Island Railway. It was here that travelers transferred to ferryboats to Manhattan. The station was a Mediterranean-style building, possibly designed as a tribute to Italian laborers who built it. (B&O Railroad Historical Society.)

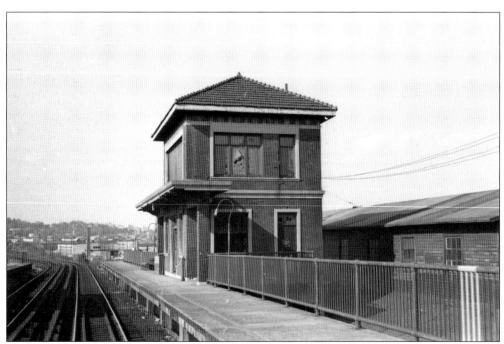

The original station was razed during the grade-crossing removal project of the 1930s. This brick tower and concrete platform replaced it. (Robert A. Miller.)

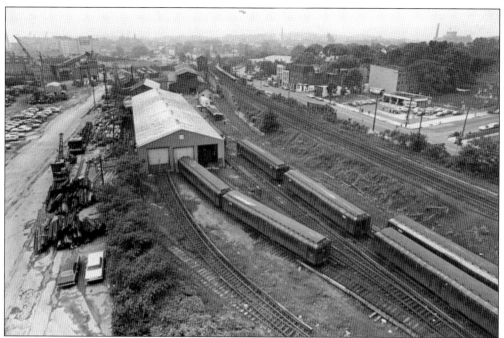

This aerial photograph from June 4, 1973, shows all the major facilities at the Clifton Shops. The building at center is the electric car shop. Several multiple-unit cars, nearing their 50th birthday, are being prepared for their last trip. The cars will be moved to New Jersey and scrapped. (Photograph by Steve Disanto, courtesy Tom Flagg.)

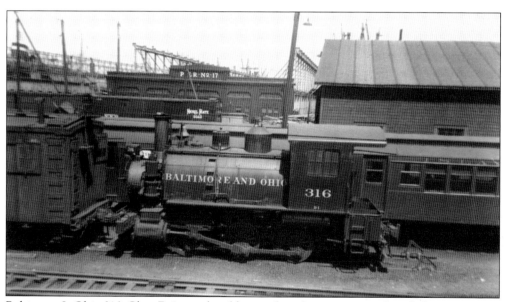

Baltimore & Ohio 316, Class D-1 was the oldest working locomotive on the whole B&O system when it was photographed at Clifton Shops in 1945. It was built by the New Jersey Locomotive & Machine Works in 1864. (Photograph by W.J. Edwards/David Keller Archive, courtesy Edward F. Bommer.)

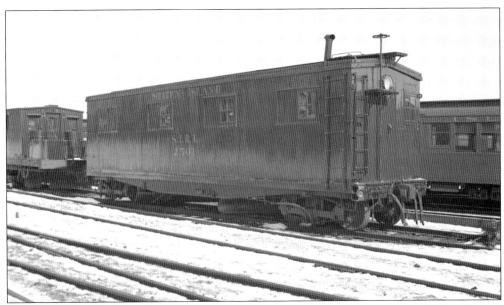

Snow removal has always been a major challenge for commuter railroads. The SIRT fashioned flanger X501 from a damaged Pennsylvania Railroad flatcar. Plows were mounted behind the trucks. The car was photographed by George E. Votava at Clifton in February 1936. (David Keller.)

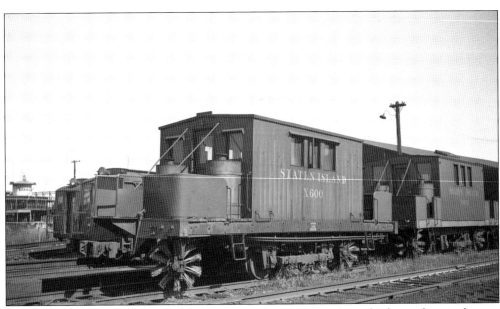

The SIRT used the two snow sweepers pictured here to keep the rails clean when inclement weather threatened to slow operations. The sweepers also applied chloride deicer to the rails. (Photograph by George E. Votava, courtesy David Keller.)

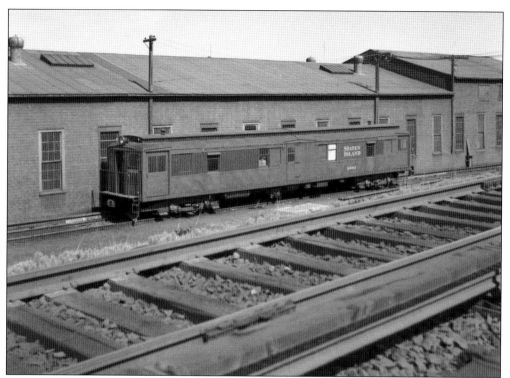

Snowplow X602 was rebuilt in 1948 from multiple-unit electric car No. 363, which got scorched in the St. George fire. A platform with railing was added to the front of the car, and plows were added underneath. It was spotted by the supply shed at Clifton Shops on May 3, 1952. (Photograph by W.V. Faxon Jr., courtesy David Keller.)

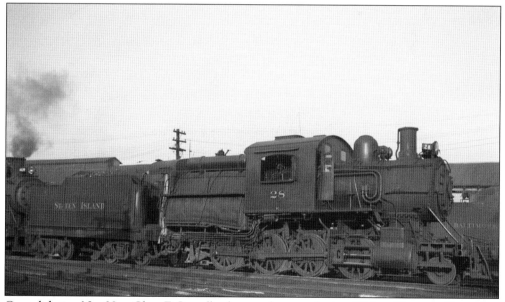

Consolidation No. 28, a Class E Camelback, was photographed at Clifton Shops on December 3, 1938. The locomotive was built by Alco Cooke in 1906. (Photograph by George E. Votava, courtesy David Keller.)

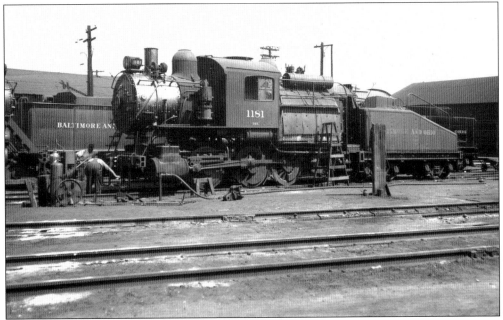

Baltimore & Ohio No. 1181, Class D-23, is one of five Camelback-type locomotives specifically built for Staten Island/New York Terminal service. The locomotive was being serviced at Clifton when this photograph was taken on August 29, 1945. (Bob's Photos, courtesy Edward F. Bommer.)

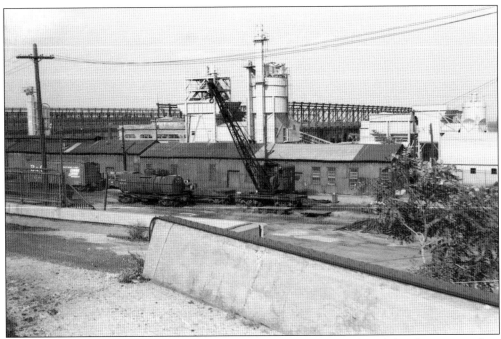

An interesting collection of nonrevenue cars is on display outside of the Clifton locomotive shop on this day in 1962. The tank car, B&O X421, was used in fuel service. A wheel car and crane stand nearby. (Robert A. Miller.)

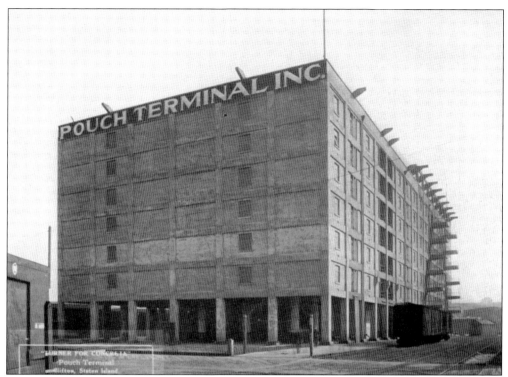

Pouch Terminal was a warehouse and pier complex that was located just south of the Clifton Shops. It opened in 1916 and had rail service. It interchanged cars with the B&O at Clifton. (Author.)

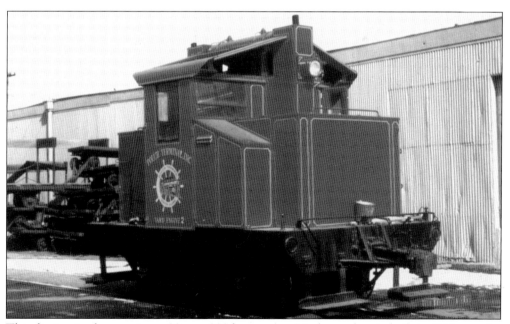

This diminutive locomotive, a 30-ton, 200-horsepower Mack gas-electric built in 1929, was the main power at Pouch Terminal. It was painted a fancy red with yellow trim when this photograph was taken in March 1958. (Edward F. Bommer.)

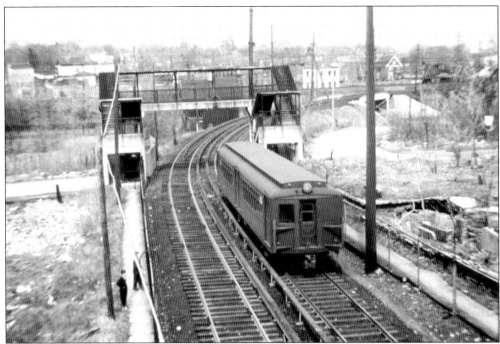

South of Clifton Station, the East Shore Subdivision extended to South Beach. This was the shortest branch on the island and the first to be electrified in March 1925. On March 31, 1953, the last day of service, a single car heads to Clifton Junction. The Lynhurst Avenue pedestrian crosswalk is at center. (David Pirmann.)

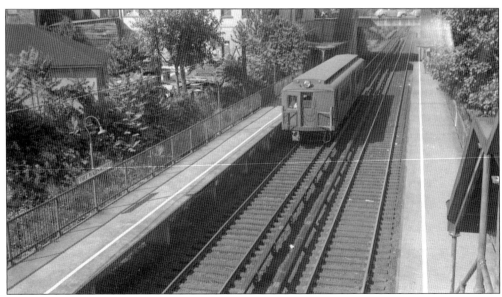

Single-car trains reveal that the East Shore Subdivision was lightly traveled. In 1948, a car bound for South Beach pauses at the Fort Wadsworth Station. (Photograph by W.J. Edwards, courtesy David Keller.)

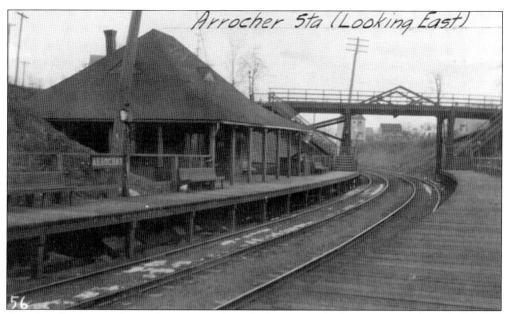

Arrochar Station was located in a cut, and its platforms were built on a sweeping curve. In 1911, this section of Staten Island looked very different than today. The Verrazano-Narrows Bridge toll plaza now occupies most of this site. (B&O Railroad Historical Society.)

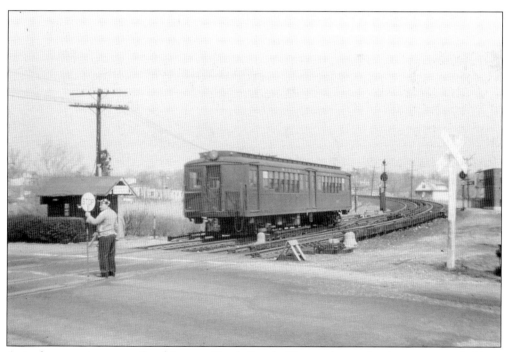

A single-car train crosses Sand Lane at South Beach. The grade crossing here was guarded by a single gateman. The electrical substation for the line is visible at far right. (David Pirmann.)

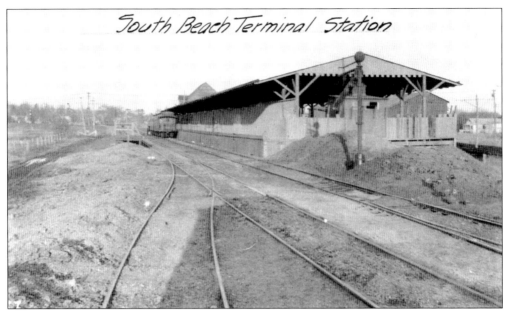

The South Beach Station is seen here in 1911. South Beach was a popular summer resort destination for families from the city. Sandy ballast is visible between the rails. (B&O Railroad Historical Society.)

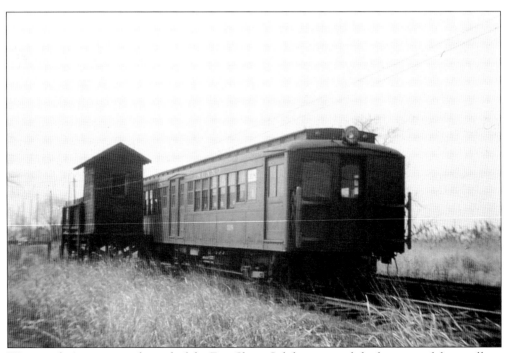

Wentworth Avenue was the end of the East Shore Subdivision and the location of the smallest, easternmost station on the B&O system. Trains returned to St. George by going through spring switches in a crossover near the end of the track. (David Pirmann.)

Eight
THE PERTH AMBOY SUBDIVISION

The Perth Amboy Subdivision starts at Clifton Junction and runs south (timetable-east) to Tottenville. At one time, passengers could transfer at Tottenville for a ferry bound for Perth Amboy, New Jersey. The building at left belongs to the Louis DeJonge Company, a paper product manufacturer. The freight sidings extended inside the building. (Thomas R. Flagg.)

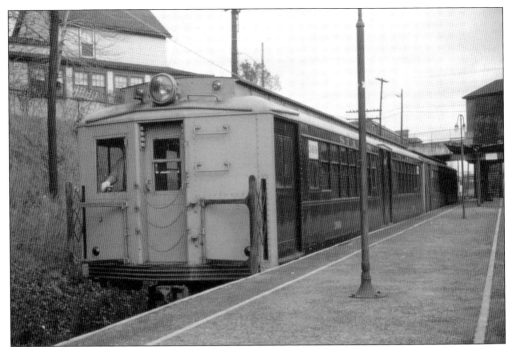

In 1946, the B&O issued a directive that stated all passenger equipment should be painted blue. The SIRT did not begin painting its MUE cars blue until 18 years later. Motor No. 369 wears a fresh coat of blue and gray as it pauses with a Tottenville-bound train at Grasmere Station in 1964. (David Pirmann.)

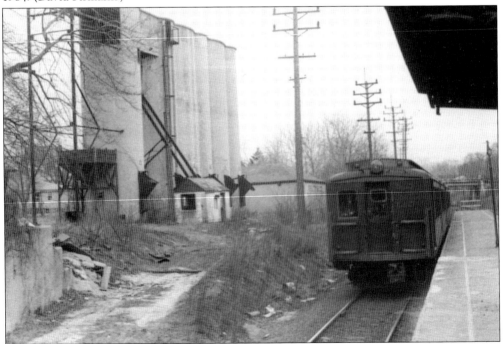

In 1965, a St. George–bound train stops at the Grasmere Station. The F.E. Litke Coal Company is visible at left. Its siding had a capacity of five coal hoppers. (Tom Griffiths.)

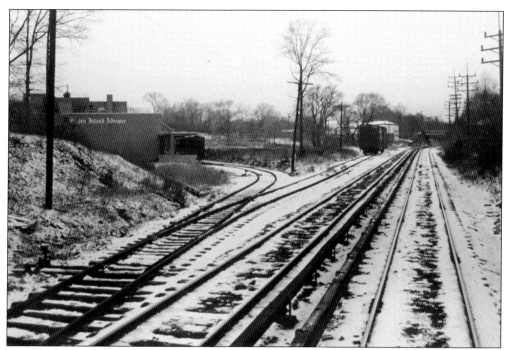

The *Staten Island Advance* newspaper received rolls of paper in boxcars. A car is spotted at the covered loading dock in this January 1972 photograph. (Thomas R. Flagg.)

A Tottenville-bound train enters Old Town Station in early winter 1965. The station was originally known as Garretson's, named after a family that had lived in the area since the late 1600s. (Tom Griffiths.)

The view in this photograph of the Old Town Station looks north. The station had wood-covered stairways and concrete platforms. The main line crossed over Old Town Road on a girder bridge. (Robert A. Miller.)

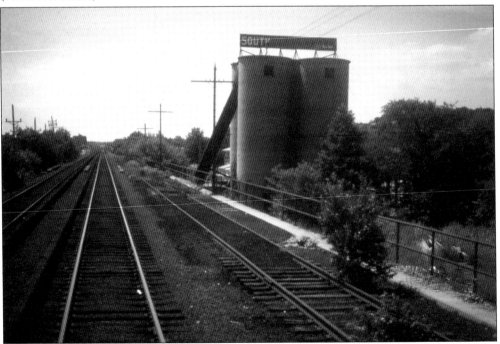

Southfield Coal & Ice Company shared a siding with the Dongan Hills Coal Company. Hopper cars dropped the coal load into a pan installed between the rails. The covered conveyor transported the coal into the silos. (Thomas R. Flagg.)

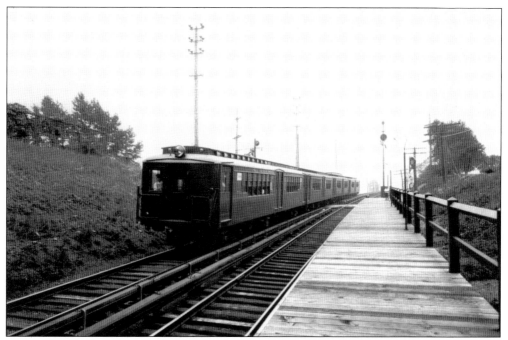

It is 1925, and a brand-new color-position light signal is being installed at the Jefferson Avenue Station. The SIRT was one of the first B&O lines to have the experimental signal installed. The electric cars at left were delivered in the same year. (James Mischke collection, courtesy Edward F. Bommer.)

Grade crossings were quickly becoming dangerous intersections, as the island's population began to grow in the 1960s. Here, a woman waits to cross the tracks near Grant City Station in 1964. (Robert A. Miller.)

A flagman was employed to protect this grade crossing during the construction of a shoo-fly track. The major grade-crossing elimination project began in the 1930s was not completed until almost 30 years later. (Robert A. Miller.)

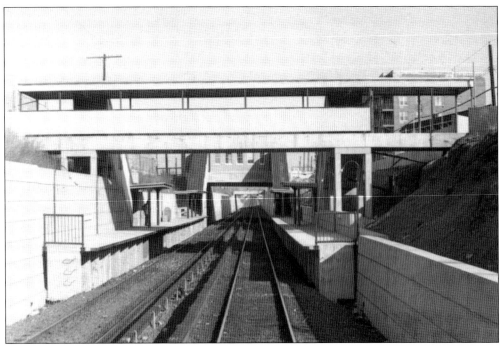

The new Grant City Station was dropped into a cut when the grade crossings were eliminated. This is how the station looked in 1969. (Tom Griffiths.)

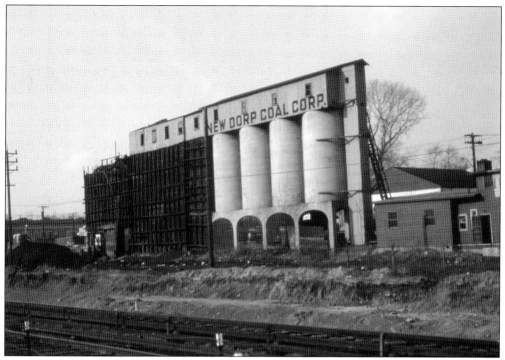

Almost every town on the island had its own coal dealership by the 1920s. The silos of the New Dorp Coal dealership were clustered lengthwise and served by a single siding. The bays under the silos allowed for quick loading of trucks. (Robert A. Miller.)

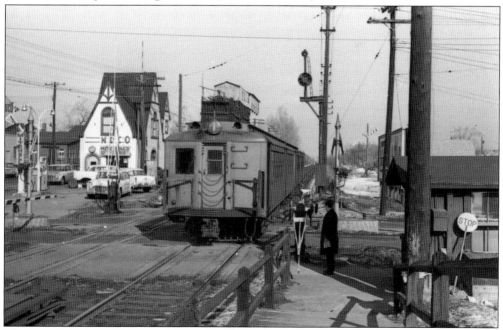

The gates at New Dorp Lane protected pedestrians as well as vehicles from crossing the tracks at train time. In winter 1962, the Tudor-style Sunoco station was still a fixture at trackside. Mitchell's Car Service and its Checker cabs crowd an adjacent lot. (Robert A. Miller.)

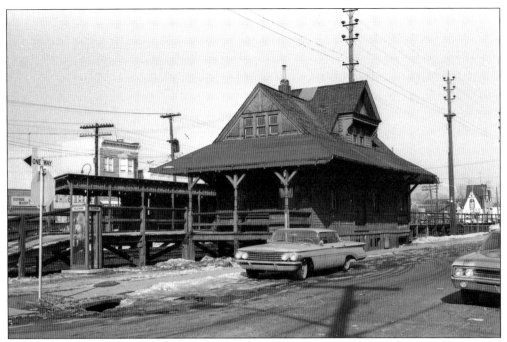

The New Dorp Station was built in 1889 by real estate developers Hughes and Ross, who desired a "nice depot" at which prospective homebuyers could arrive. This view of the rarely photographed street side was taken from South Railroad Avenue in winter 1962. (Robert A. Miller.)

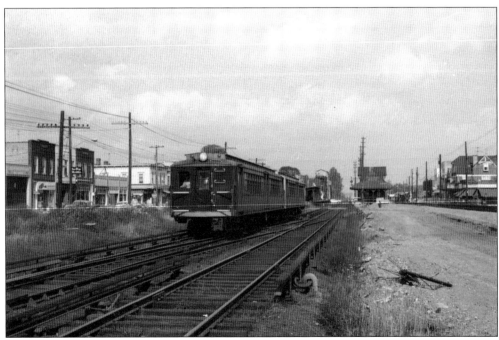

Change is in the air in this 1965 photograph. A Tottenville-bound train plies the old main line as a bypass track is being installed at right. The aging New Dorp Station will be moved to Historic Richmondtown, where it will be repainted and preserved. (Robert A. Miller.)

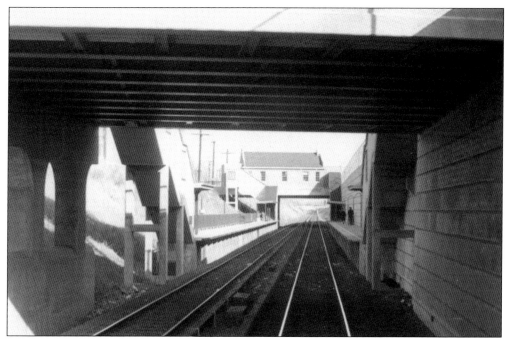

In 1967, New Dorp Station was dropped into a cut, and the wood station house was replaced by a brick structure on New Dorp Lane. The station design was identical to those built nearly 30 years earlier, during the 1930s grade-crossing removal project. (Tom Griffiths.)

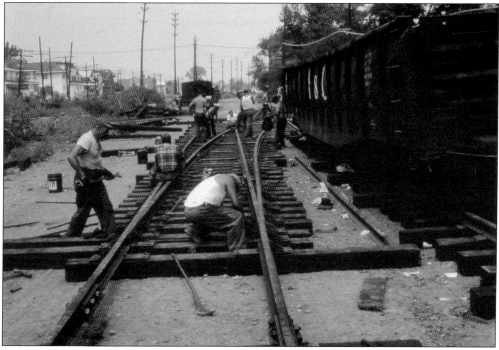

Installation of the bypass track is well under way in this photograph taken at Oakwood Heights in 1965. The rails and ties were delivered in the B&O gondola at right. (Robert A. Miller.)

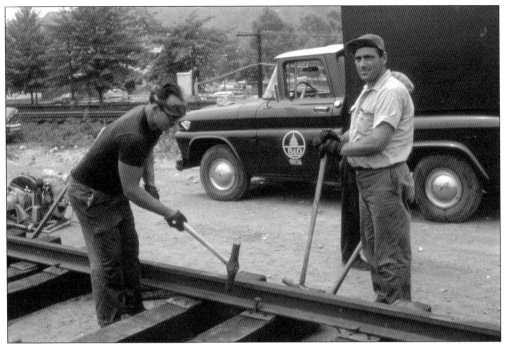

A track worker installing a bypass track pauses to pose for a photograph. The B&O pickup truck in the background carried the track-laying tools to Oakwood Heights Station on this day in 1965. (Robert A. Miller.)

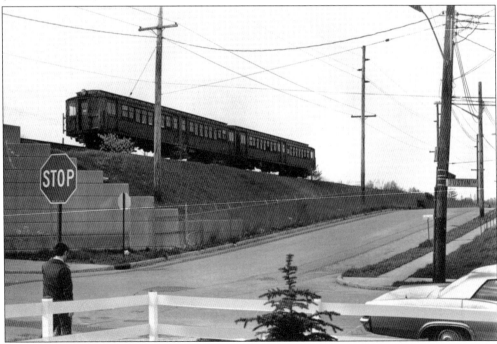

A two-car train, bound for St. George, leaves the Bay Terrace Station. Train operators on the line were known to back up trains for passengers who were running late. This personal service was unique to the B&O. (Gaspar Pitanza.)

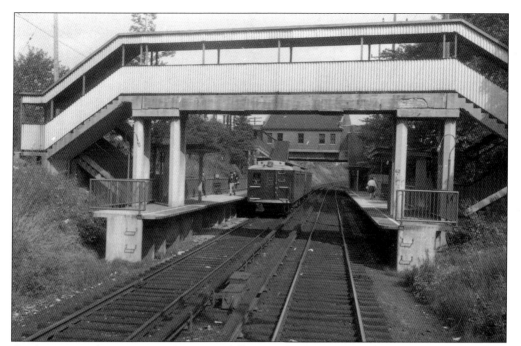

Grade-crossing elimination work at Great Kills proved to be extremely difficult in the early 1930s. Workers had to dig 30 feet below grade to clear Gifford's Lane; the right-of-way was found to be laced with underground springs and deep quicksand. (Robert A. Miller.)

In August 1973, a Penn Central boxcar derailed near Great Kills Station. It was dragged, unbeknownst to the freight crew, for nearly a quarter of a mile. The station platforms, ties, and third rail were severely damaged by the derailed car. The freight train was heading for Nassau Smelting near Tottenville. (Tom Griffiths.)

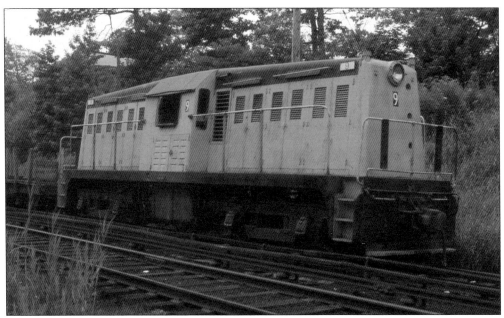

Whitcomb switcher No. 9 was sent in with a maintenance-of-way train to help remove the derailment shown on the previous page. The 65-ton engine had a long history; it served in Italy with US Army Transportation Corps and then it worked for the South Brooklyn Railway for nearly 30 years before being transferred to Staten Island by the MTA in 1972. (Tom Griffiths.)

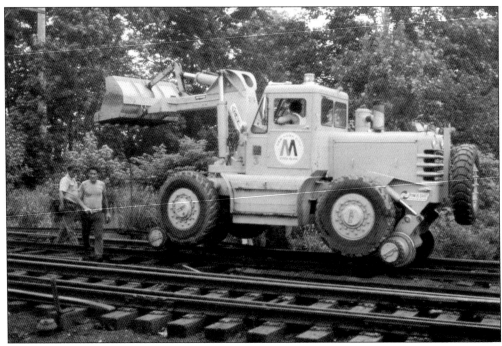

This front-end loader could ride the rails as well as the road. It was used in clearing debris from the right of way and for ballasting small sections of track. It sports an MTA Staten Island herald on its cab. (Tom Griffiths.)

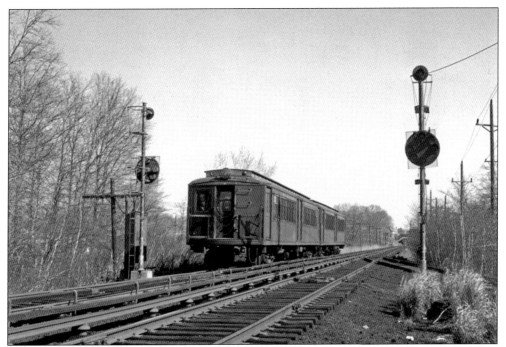

Framed by two B&O color-position light signals, a Tottenville-bound train rumbles through Eltingville in 1970. (Thomas J. Nemeth.)

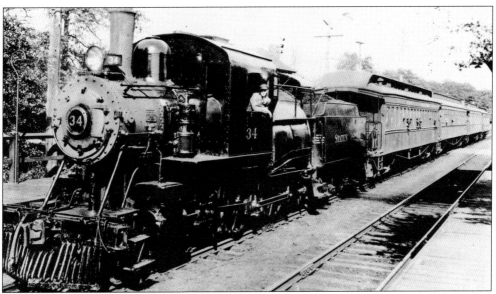

Staten Island Railway 34, a Class F locomotive, pulls a train of borrowed B&O coaches at Annadale in 1923. The coaches, renumbered in the 200 series and modified for Staten Island service, were only used on the Perth Amboy Subdivision. (Thomas Norrell collection, courtesy Edward F. Bommer.)

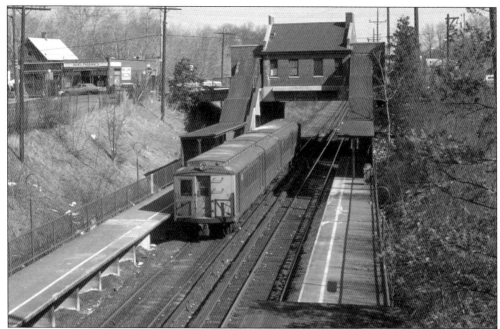

On February 22, 1970, a Tottenville-bound train pauses at the Annadale Station. The below-grade station was constructed in the 1930s. It was named for Anna Seguine, a prominent resident and Staten Island Rail Road stockholder. (Thomas J. Nemeth.)

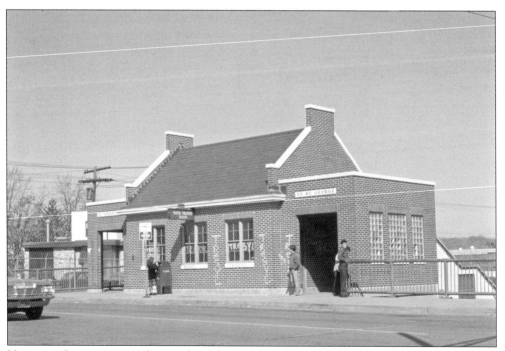

Huguenot Station is a good example of the standard-design brick station house constructed by the Staten Island Rapid Transit. The first masonry stations were erected in the 1930s, during the grade-crossing removal project. (Thomas J. Nemeth.)

The building on the embankment in this photograph is the tiny Huguenot freight house. The track that served it had a capacity of 13 freight cars. (Thomas R. Flagg.)

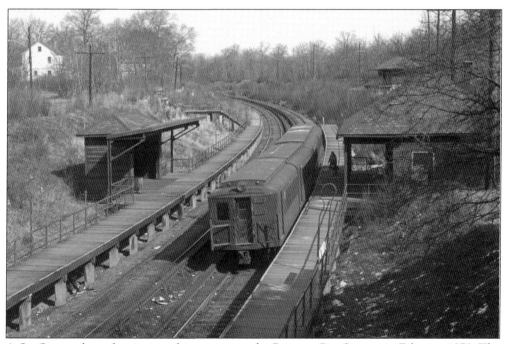

A St. George–bound train is making a stop at the Princess Bay Station in February 1970. The area was also called Prince's Bay by some locals. The stop served employees of S.S. White Dental Works, which was located a half mile away in Seguine Point. (Thomas J. Nemeth.)

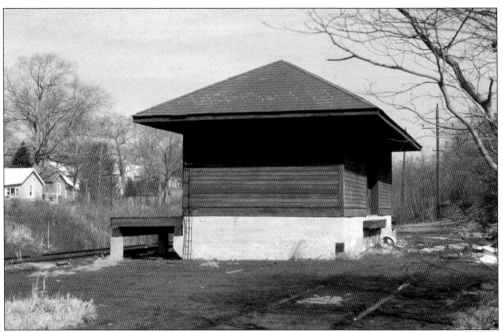

The tiny Princess Bay freight house could be reached via a trailing point switch on the St. George–bound track. Its design was similar to a standard 16-foot-by-20-foot B&O freight house. (Thomas J. Nemeth.)

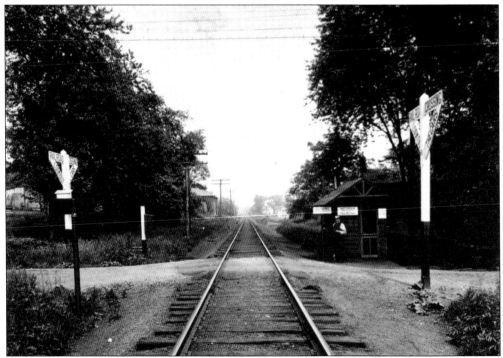

The Sharrott Road grade crossing in Pleasant Plains is the subject of this June 18, 1924, B&O valuation photograph. Before 1934, the railroad was a single-track line from Annadale to Pleasant Plains. (Photograph from Bramson Archive, courtesy Edward F. Bommer.)

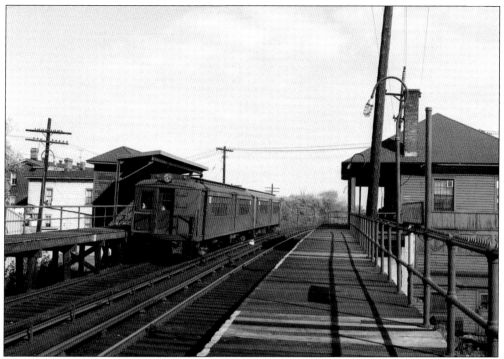

On October 18, 1964, a Tottenville-bound train stops at the elevated Pleasant Plains Station. The wood station house hosted an HO scale model railroad club in the 1950s. (Photograph by Harold A. Smith, courtesy Robert A. Miller.)

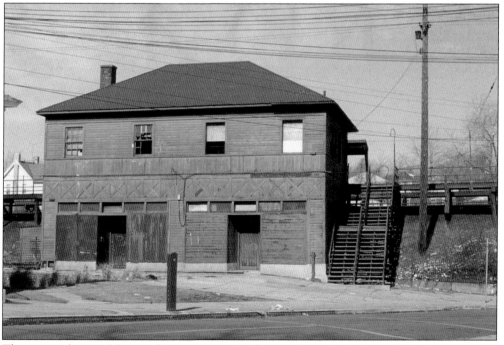

The unique design of the wood-frame station in Pleasant Plains is clearly visible in this street-side view from February 22, 1970. (Thomas J. Nemeth.)

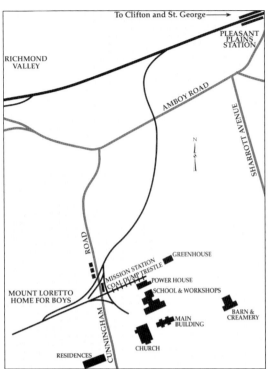

A curving branch line to Mount Loretto was built a quarter mile east of Pleasant Plains Station to reach the Mission of the Immaculate Virgin. The railroad served the Roman Catholic children's home with special passenger trains that ran to Mount Loretto every third Sunday until the late 1930s. (Edward F. Bommer.)

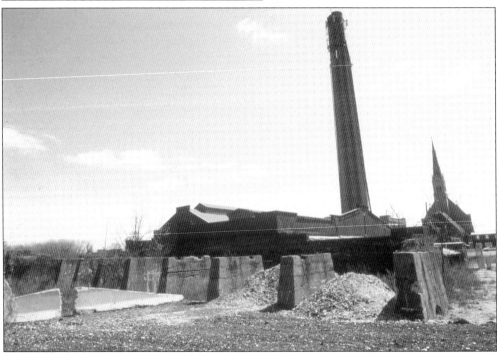

Mount Loretto received freight shipments until the late 1950s. Coal hoppers were spotted and unloaded on the coal dump trestle pictured here. The line was abandoned in the early 1960s, and the tracks were removed soon after. The concrete trestle still stands behind the powerhouse. (Author.)

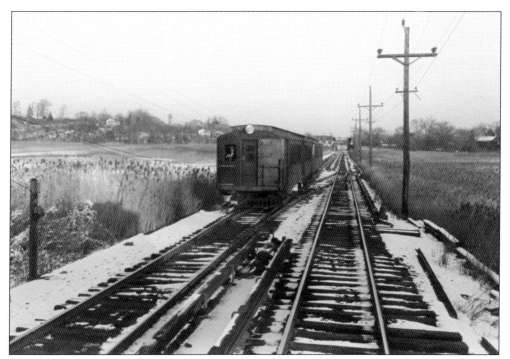

A Tottenville-bound train trundles through the marshlands near Richmond Valley. (Thomas R. Flagg.)

A spur branches off from the westbound track at Richmond Valley Station. It was built so trains could deliver supplies to the Outerbridge Crossing construction site in 1928. Later, the track served a small scrapyard owned by the Roselli Brothers. (Author.)

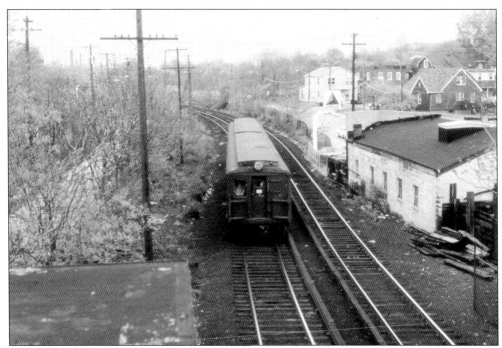

A Tottenville-bound train snakes through Nassau. The station was primarily intended for the employees of Nassau Smelting. (Author.)

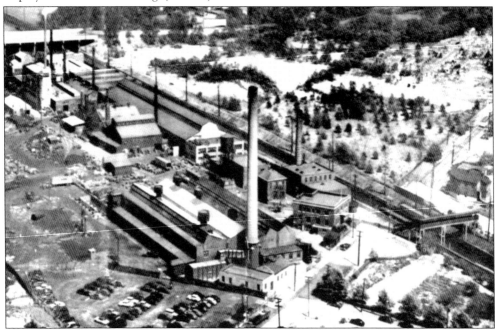

The Nassau Smelting & Refining Company, opened in 1884, was once the largest freight customer on the Perth Amboy Subdivision. It served as the salvage unit for the whole Bell Telephone System, reclaiming various nonferrous metals from obsolete phone equipment for reuse. The station platforms and overpass are visible at bottom right. The complex could handle over 70 freight cars. (Edward F. Bommer.)

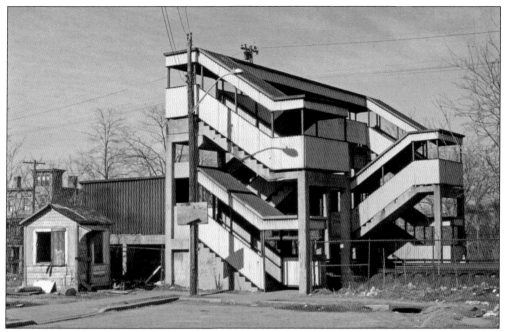

The small station at Atlantic was built for the convenience of employees of the Atlantic Terra Cotta Works. The concrete-and-metal pedestrian overpass was built in the 1930s. The small shanty that protected the original grade crossing still stands in this winter 1970 photograph. (Thomas J. Nemeth.)

Tottenville Station marked the end of the line for the Staten Island Rapid Transit Railway. The lighted sign pictured here was attached to the brick station house. (Robert A. Miller.)

The slip for the Perth Amboy ferry was conveniently located adjacent to the Tottenville Station house. From 1861 to 1948, the Staten Island Railway and SIRT operated ferry service to Perth Amboy, New Jersey. Passengers from the south end of the island frequently commuted to New York City by catching a train in New Jersey. (Robert A. Miller.)

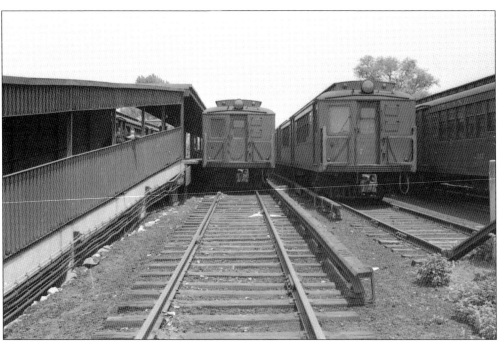

The yard at Tottenville is crowded with multiple-unit electric cars on this day in 1962. The ramp at left led passengers to nearby Bentley Avenue and the ferry house. (Robert A. Miller.)

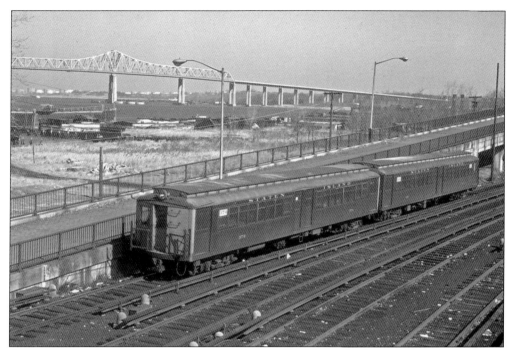

A two-car train from St. George arrives at Tottenville. The multiple tracks at right belong to the small passenger car yard. The Outerbridge Crossing to New Jersey looms in the background. (Thomas J. Nemeth.)

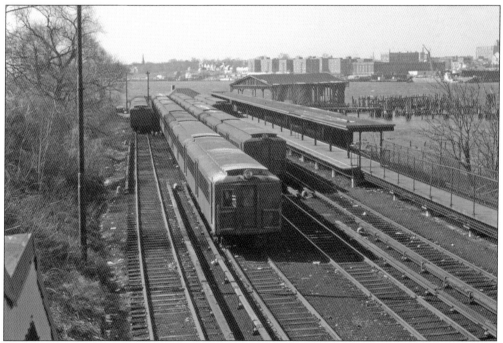

Trains on the four stub-end yard tracks at Tottenville wait to be called into duty on February 22, 1970. The island-type platform and dilapidated ferry house are visible at right. (Thomas J. Nemeth.)

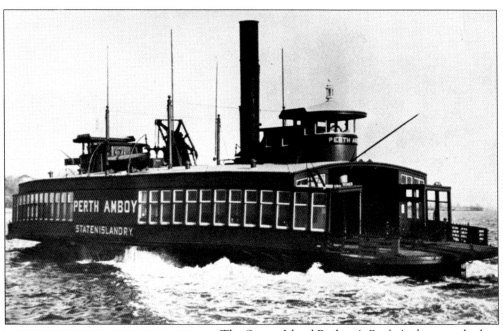

The Staten Island Railway's *Perth Amboy* was the last ferry to operate between its namesake town in New Jersey and Tottenville. It was built by Robert Palmer & Son of Noank, Connecticut, in 1907. It made its last trip on October 14, 1948. (Edward F. Bommer.)

THE
Staten Island Rapid Transit Railway Company

PERTH AMBOY
SUB-DIVISION

Time Table

Effective 12.01 A. M.
FEBRUARY 4, 1934.
(Subject to change without notice.)

M. L. McELHENY E. W. MURRAY
Superintendent Gen'l Traffic Agent
St. George, S. I. New York, N. Y.

W. G. CURREN
General Manager

GENERAL OFFICE
25 BROADWAY, NEW YORK

25m. 2-4-34.

This is a public timetable for the Perth Amboy Subdivision from February 4, 1934. (Author.)

Nine
STATEN ISLAND RAILS IN THE 21ST CENTURY

In April 1985, the B&O sold its Staten Island line to the Delaware Otsego Corporation. Freight traffic was handled by the New York, Susquehanna & Western Railroad until 1991. In this 2001 photograph, rusty rails and rotting ties sit dormant at Arlington Yard. The track was plagued by poor drainage in the later years. (Author.)

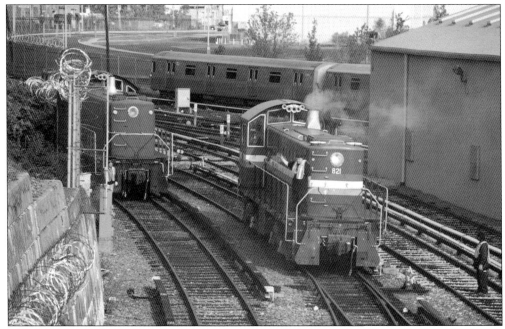

The MTA retired work-train locomotive No. 9 in 1985. To replace the aging unit, the Staten Island Rapid Transit Operating Authority purchased Alco S-2 No. 821 in the same year. The Alco S-1 at left is former Long Island Rail Road No. 407, which was transferred to Staten Island in 1976. (Author.)

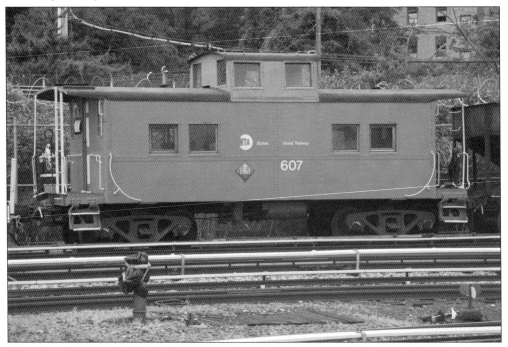

In 1994, the Metropolitan Transportation Authority reinstituted the line's original name, and the passenger portion of the line is now known as the MTA Staten Island Railway. This Northeastern-style caboose is used in work-train service. It came to Staten Island in the 1980s. (Author.)

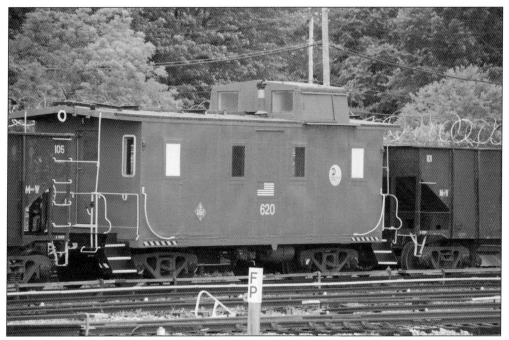

Staten Island Railway No. 620 is a heavily modified steel offset cupola caboose. The car seen here at Clifton is used in work-train service. (Author.)

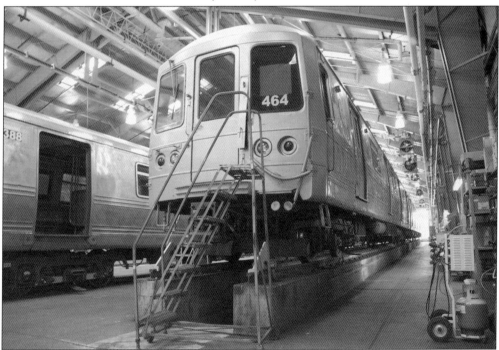

Car No. 464 is spotted over the inspection pit in the electric car shop at Clifton. The R-44 SI cars were first delivered to Staten Island by the St. Louis Car Company in 1972. Staten Island cars were built to Federal Railroad Administration standards and were outfitted with grab irons, required by a freight-carrying road. (Author.)

In 2009, the Staten Island Railway took delivery of four BL20G locomotives built by Brookville Equipment Company. The high-tech engines are used in work-train service and use computer technology to rate the condition of the rails underneath. The aging Alco switchers were sold to the Catskill Mountain Railway. (Author.)

In 2010, BL20G No. 777 was named *Vern* in tribute to a beloved employee of the Clifton Shops who passed away. The heavy-duty crane is used for lifting car bodies for quick and easy truck replacement. (Author.)

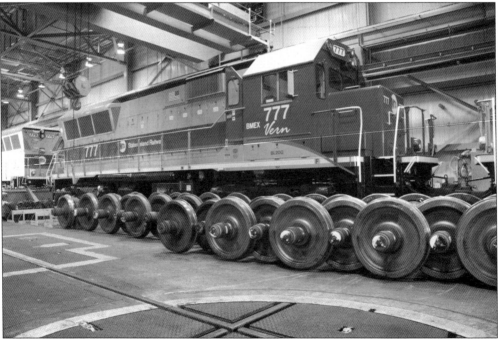

The old Baltimore & New York Subdivision in New Jersey became dormant when it was abandoned in 1992. Bayway Refinery, the largest customer on the line, was in dire need of rail service. A portion of the line was revitalized and is now operated by the Morristown & Erie Railway. In 2009, Alco C420 No. 19 waits for service over Route 1 in Linden. (Author.)

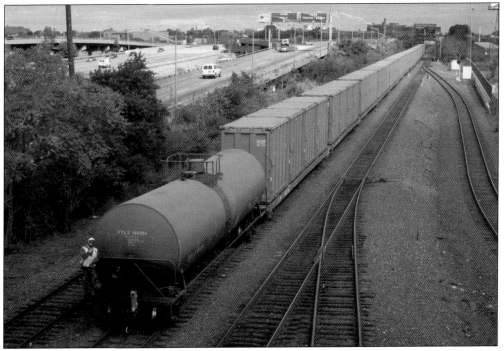

A train backs up on Conrail's Chemical Coast secondary track in Elizabeth, New Jersey. Since 2006, trains from Staten Island use the track at far right to gain access to Oak Island Yard in Newark. Trains coming over the Arthur Kill Bridge no longer run to Cranford Junction. (Author.)

In the late 1990s, Staten Island politicians began to seriously look into revitalizing the island's freight railroad. In 2003, the derelict track at Arlington was removed and then replaced in 2005 with new roadbed and heavier rail built to modern standards. Here, a prefabricated switch is being installed under the new South Avenue overpass. (Author.)

In 2005, the old Travis Branch was being renovated and extended to the New York Sanitation dump at Fresh Kills. Seen here in February 2006, new tracks are being installed near Meredith Avenue. The track layout here follows the original 1957 B&O design for a pair of runaround sidings just north of Neck Creek. (Author.)

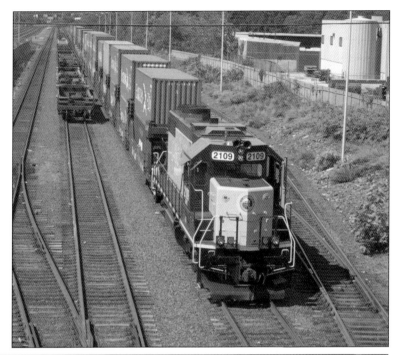

On October 4, 2006, GP38-2 No. 2109 was delivered to the New York Container Terminal in Howland Hook. The locomotive was the first train to cross over the Arthur Kill Bridge in over 15 years. Shown here at Arlington in September 2011, it is used to move double-stack container cars from Howland Hook to Arlington Yard. (Author.)

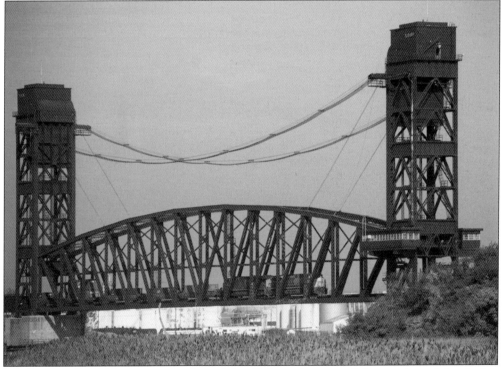

On October 21, 2009, close to the date of the 50th anniversary of the opening of the Arthur Kill Vertical Lift Bridge, a freight train led by CSX No. 429 crosses into Staten Island. The train is pulling a long string of double-stack container cars, followed by empty trash container cars. (Author.)

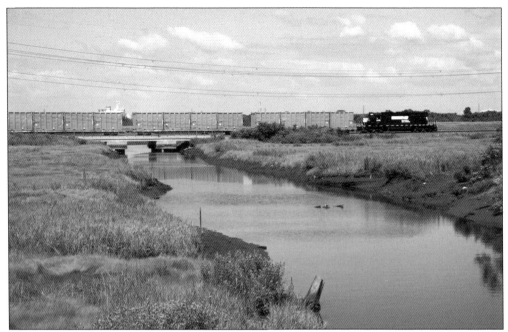

Prior to reactivation in 2007, all of the trestles on the Travis Branch were replaced with robust concrete bridges. A trash train, led by Norfolk Southern SD40-2 No. 3376, plies the rails over Saw Mill Creek in Chelsea on June 15, 2012. Staten Island is considered Conrail Shared Assets territory; both CSX and NS locomotives operate on the line. (Author.)

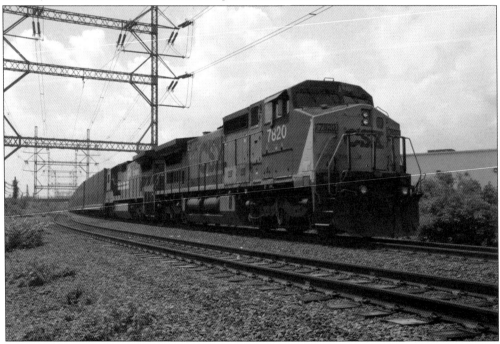

A trash train led by CSX and Conrail six-axle power waits at the South Avenue grade crossing on the Travis Branch. The cars will be added to a longer train at Arlington Yard before returning to New Jersey. (Author.)

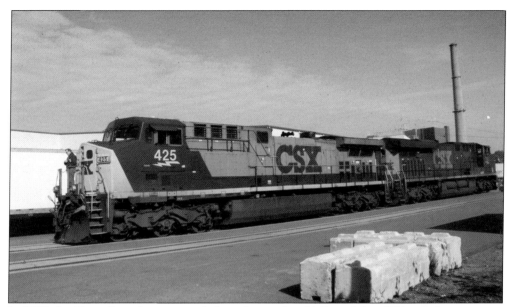

In 2005, the Travis Branch was extended south past the old Consolidated Edison plant to a new yard at Fresh Kills. On October 21, 2009, CSX GE AC4400CW No. 425 and CSX GE ES44AC No. 760 run light to the new trash-transfer facility. Pratt Industries, a manufacturer of cardboard, has access to the railroad for shipments. The paper factory has yet to use it. (Author.)

The new yard at Fresh Kills was built to serve the trash-transfer station operated by the New York City Department of Sanitation. Regular service to the facility began in April 2007. Unit trains made up of bright orange container flatcars serve the facility quite frequently—sometimes, up to five times daily. (Author.)

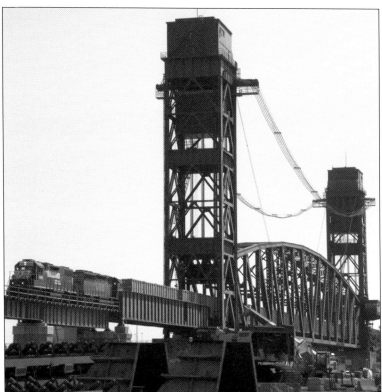

In August 2014, Norfolk Southern GP38-2 No. 5283 pulls a short train over the Arthur Kill Lift Bridge into Elizabeth, New Jersey. The materials in the foreground belong to the construction project started by the Port Authority to replace the 85-year-old Goethals Bridge. (Author.)

In October 2013, the MTA and elected officials participated in the ground breaking for the first new Staten Island Railway station since MTA took over the line in 1971. The station is the first to include a park-and-ride lot nearby. Arthur Kill Station, opening in late 2015, will replace the existing stations at Atlantic and Nassau on the Perth Amboy Subdivision. (Author.)

BIBLIOGRAPHY

Bogart, Stephen. "Little-Known Railroad." *Trains* (February 1951): 20–26.
Bommer, Edward F. "A B&O History Mystery." *Sentinel* 34, 1 (2012): 26–30.
———. "The Railroad Shops At Clifton: Serving Staten Island for 150 Years." *Sentinel* 25, 2 (2003): 9–18.
———. "Staten Island Rapid Transit Railway Company: A Foot in the Door." Cooperstown, NY: handout, 1998.
Flagg, Thomas R. *New York Harbor Railroads in Color, Volumes 1 and 2*. Scotch Plains, NJ: Morning Sun Books, 2000.
Griffiths, Tom. "The End of the B&O Line." *Sentinel* 32, 1 (2010): 25–30.
Harwood, Herbert H. *Royal Blue Line*. Baltimore: The Johns Hopkins University Press, 2002.
Leigh, Irvin, and Paul Matus. *Staten Island Rapid Transit, 1860–1965*. Brooklyn, NY: Silver Leaf Rapid Transit, 1965.
Owen, Gary. *S.I.R.T. South Beach Line Page*. Last modified 2013. www.gretschviking.net/GOSIRTPage1.htm
Pirmann, David. www.nycsubway.org/wiki/SIRT_Staten_Island_Rapid_Transit, last modified October 2014.
Pitanza, Marc A. "Staten Island Rail Revival." *Railpace Newsmagazine* (December 2006): 10–11.
Scull, Theodore W. *The Staten Island Ferry*. New York: Quadrant Press, 1982.
"Staten Island Sojourn." *Locomotive Quarterly* XXII, 2 (Winter 1998–1999): 39–53.
Teichmoeller, John. "Baltimore and Ohio Railroad Diesel Tugs." *Sentinel* 23, 1 (2001): 2–35.
Travis, Rich. "From Chessie To Suzie-Q." *Railpace Newsmagazine* (March 1986): 18–26.

Discover Thousands of Local History Books
Featuring Millions of Vintage Images

Arcadia Publishing, the leading local history publisher in the United States, is committed to making history accessible and meaningful through publishing books that celebrate and preserve the heritage of America's people and places.

Find more books like this at
www.arcadiapublishing.com

Search for your hometown history, your old stomping grounds, and even your favorite sports team.

Consistent with our mission to preserve history on a local level, this book was printed in South Carolina on American-made paper and manufactured entirely in the United States. Products carrying the accredited Forest Stewardship Council (FSC) label are printed on 100 percent FSC-certified paper.